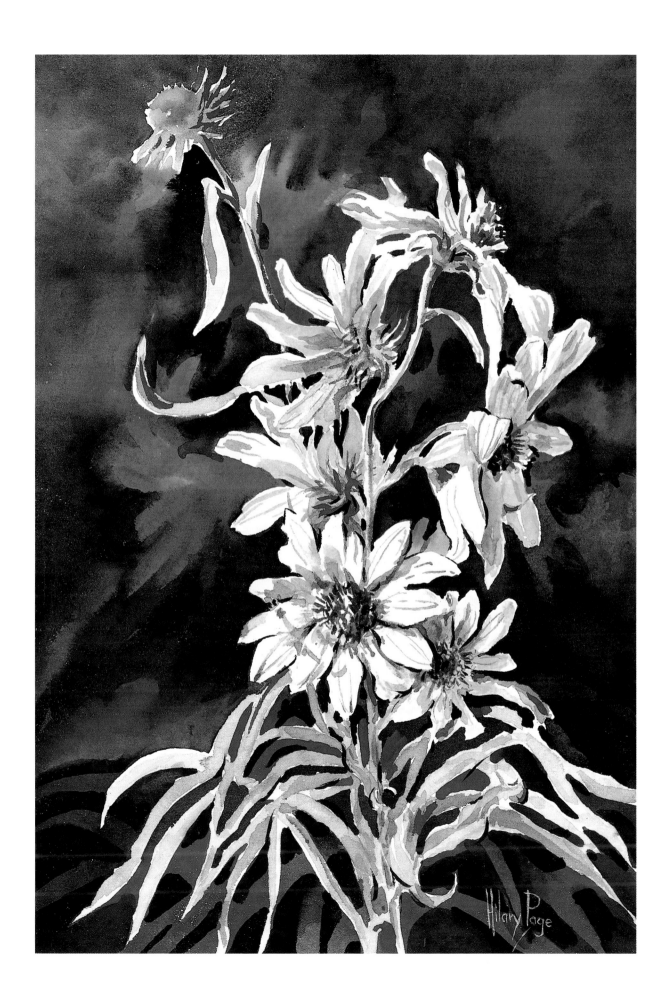

COLOR

RIGHT FROM THE START

Progressive Lessons in Seeing and Understanding Color

HILARY PAGE

WATSON-GUPTILL PUBLICATIONS/NEW YORK

LONG TALL TEXAN, 30 × 22" (76.2 × 55.9 cm).

Introduction

Color rivets our attention, creates mood, provides a pleasurable experience, imparts information, and serves to identify objects by setting them apart, one from another. More than to show the painter how to elicit such reactions from the viewer, *Color Right from the Start* explores the fascinating subject of color in art from three main aspects—namely, "objective color," which is related to how colors appear and is measurable by instrumentation outside the eye; "optical color," which is induced by peculiarities related to how the eye works, and "practical color," which is related to pigment colors and how they handle.

Thus this book provides both a practical and a theoretical discussion of the mystery of color in art in a progressive and easy to understand way. It is also a reference book containing a great deal of up-to-date information about color, presented clearly and logically, and with copious illustrations. While aimed towards the intermediate, "rusty," and even beginning painter, it can also be used as a manual by teachers and college students and as a tool for the professional artist. Indeed, this is a comprehensive overview of color for the artist not available in any other single art book. By the end of this book, the reader has an overall understanding of what color is all about and is in a position to use it creatively.

HOW THE BOOK IS ORGANIZED

The first chapter examines what color is; it presents both an objective assessment of color and explains color vision—that is, optically induced color sensations. The significance of this information to an overall understanding of color in art becomes apparent as the reader progresses. The color phenomena described are referred to constantly throughout the text.

The second chapter describes color-ordering systems, including various color wheels, and shows how to match and mix colors. Concrete examples of optical contrast phenomena are examined. The reader explores this information in practical exercises that illustrate the theory and produces tools for reference in future practical lessons.

The third chapter covers color pigments. Included are sections on chemical groups, testing methods to determine a paint's handling characteristics, and information on reflectance curves. Curves for over forty commonly used pigments are included in the book and arranged by color group for comparison. Practical application is again included with the theory, to aid in remembering the information.

The remaining chapters provide information about color arranged by color group, starting with "colors without color," and then according to the spectrum, starting with yellow. Each includes information about the chapter's pigment colors, reflectance curves, samples showing how each pigment handles, and information about each paint. This is followed by lessons on color in which material is synthesized and put to practical application.

The demonstrations within each chapter are arranged progressively. That is, the first demonstration of the chapter is technically easier than the others. Often the demonstrations describe the stages of a painting in terms of the thought process, particularly related to color use.

Readers can then adapt the steps and incorporate the color information into their own compositions.

A wide range of subjects is covered to give the reader a store of reference material. The subjects include colored shadows, imaginative abstracts, brightly colored translucent flowers, flesh colors, colored glass, skies and interior and exterior scenes, and much more. Although the demonstrations are in watercolor, the color lessons are adaptable to all colored mediums.

HOW TO USE THE BOOK

For an overall idea of what color is about, readers should read the first three chapters closely for a basic understanding of color and then the theoretical information at the beginning of each lesson.

To assimilate the information fully, readers should actually paint the practical exercises described in "Knowing Your Colors," the second chapter, and work through the first demonstration in each chapter; these are easier and give more practical information about techniques. Finally, they should pick topics of particular interest until all aspects of color covered in the first chapter have been put to practical application.

For those wanting reference material especially related to pigment color, "Knowing Your Pigments," the third chapter, and then the pigments information in the chapters on particular colors should prove very helpful.

Upon completion of the material, readers will be ready to lay the book aside and confidently enter the sensuous world of color, enjoying it right from the start of the intoxicating painting process.

LIGHT, COLOR, AND SIGHT

Our venture into the world of color for the artist begins with two concerns: first, we find out what color is, as related to the way color is objectively measured by instruments outside the eye—this is the physics of color. Second, we examine the mechanics of color vision, examining optical color as related to the way the eye works. The functioning of the eye causes various optical phenomena known as simultaneous and successive contrast. We will see how knowledge of both "objective color" and "optical color" is essential if we are to understand how to use color in art.

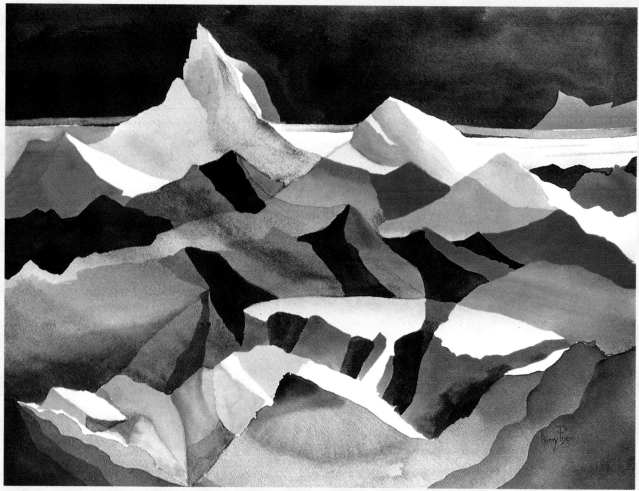

ABSTRACT MOUNTAIN IV, 22 × 30" (55.9 × 76.2 cm).

LESSON 1 *The Physics of Color*

Black and white were once thought to be the source of all color. Crimson was a combination of a certain amount of blackness with the addition of firelight or sunlight. For many centuries these views held sway with color theorists, including Aristotle and Goethe, who wrote his *Theory of Colors* as late as 1810. Seneca, in A.D. 100, had separated light into colors of the spectrum with a prism.

The modern understanding of color began in 1666, when Sir Isaac Newton unequivocally showed that color is a property of light. He refracted (bent) a small beam of sunlight through a prism and projected the emerging bands of colors onto a white screen. To show that the colored bands are a part of white light rather than the result of some action of the prism, he made a hole in the screen where the bands of color were displayed. The hole allowed only the yellow portion of the spectrum to shine through. In the path of this yellow ray he placed a second prism. The color of the emerging light still appeared yellow. Color that could *not* be refracted further by a second prism to produce another color he called *homogeneous* color. Later it was called *spectral* color.

Newton also experimented to learn about the composition of color and how we perceive it. This is of particular importance to pigment-using artists, because it tells us about color mixing. He directed a band of green light from one prism onto a white screen and a band of red light from the other prism onto the same spot on the screen. The resulting color was yellow. He then made a hole in the screen and directed the mixed yellow through a third prism. The resulting color was not yellow but a reappearance of the bands of

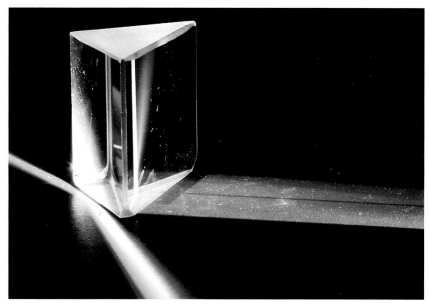

In ancient times the phenomenon of the spectrum was well known, but analysis of its significance did not take place for another fifteen hundred years. Photograph reprinted courtesy of Eastman Kodak Company.

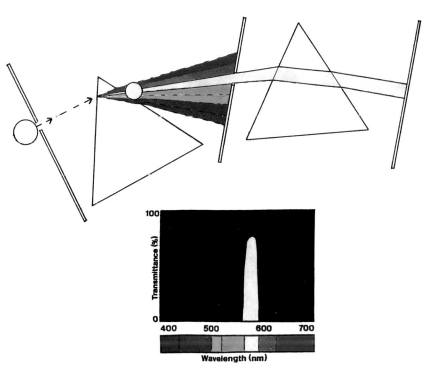

A diagrammatic representation of Newton's color experiment.

red and green rays. From this he concluded that even though our eye registers two yellows as the same colors, they may actually be constituted differently. Colors made by adding two colored lights together are now called common nonspectral colors. Pure, indivisible yellow is spectral.

Newton next analyzed why colored objects appear colored: if white light is a mixture of different-colored rays, he reasoned, then the color of an object would have to be the color of the rays that its surface reflects. Artists' pigment colors do this, as Newton described in 1730: "All coloured powders so suppress and stop in them a very considerable part of the light by which they are illuminated. For they become coloured by reflecting the light of their own colours more copiously, and that of other colors more sparingly." But what happens to the colored rays not reflected, the colors in white light that we don't see? Newton concluded that the other rays are *absorbed* by the colored surface and the color we see is color of the light that is not absorbed. This information led him to a further conclusion: the colors common to both the light and the object determine the perceived color of an object.

Newton made another startling discovery of significance to the artist while combining spectral colors. He found a color not included in the spectrum—an extra spectral color. All other spectral light-color combinations, such as red and green, produced a color that was visible on the spectrum. However, as the

Spectral and nonspectral light: a diagrammatic representation of Newton's prism experiment on yellow light, together with modern transmittance curves. Although spectral and nonspectral yellow light appear the same to our eyes, they are constituted differently as shown in the transmittance curves. Pigment color is constituted like nonspectral light-color.

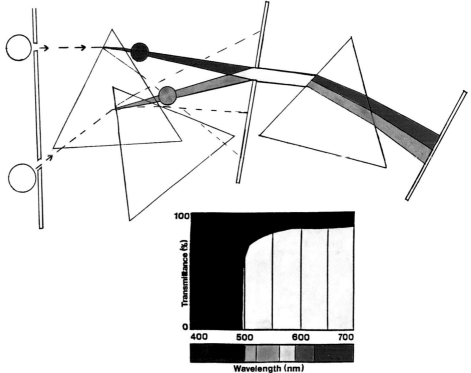

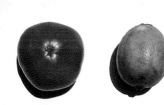

White light transmits both red and green, so objects can appear red and green when illuminated by white light. The significance of this to the artist is that as the color of the light illuminating the subject changes, the color of the object will change.

Cyan (blue) light transmits only a small portion of red and green and will thus be able to make an object appear only slightly red and green, the red appearing dull and the green taking on a blue-green appearance.

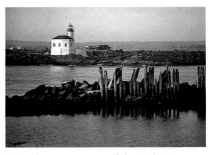

Note the appearance of the "white" lighthouse in the yellow-white late-day sunlight. This light will enhance the quality of all yellows, reds, and browns, and will detract from the color quality of blues and purples in the scene.

diagram of Newton's experiment shows, when combining red from one end of the spectrum and violet from the other, he found "the colour compounded shall not be any of the prismatic colours but a purple, inclining to red and violet."

The pigment version of this long-lost color, permanent rose quinacridone, is a major component of artists' color, for it is the balanced primary red of pigment-color mixing.

Newton also touched upon how colors are mixed: colors in light when mixed add light "more copiously," but "coloured powders"—that is, pigment-colors—"suppress and stop in them a very considerable part of the light." Here he described the difference between *additive* light-color and *subtractive* pigment-color. The former adds light, the latter subtracts. This difference between the two becomes significant as we examine color vision and pigment-color mixing.

COMPOSITION OF COLOR AND LIGHT

At this stage Newton had no clear idea of what color and light are, but he hypothesized that they were composed of tiny particles emitted by luminous bodies such as the sun or a candle. Prior understanding of color and light was limited. The Persian scientist and philosopher Alhazen (A.D. 965–1040) deduced that light rays emanate in straight lines in all directions from an illuminated surface. Light does not turn a corner.

To the artist this information is important, for it means that, apart from color seen from a direct light source—the sun, a candle, an orange sodium light—all the color around us is reflected from a surface. That indirect, reflected light enables us to see is made clear when we realize that light is invisible until it illuminates an object in its path. It's easy to conceive of this if you think

of automobile headlights at night. Their light is nothing but blackness as it travels through darkness. It only illuminates when it falls on and is reflected by objects such as road signs in its path.

Reflected colored light is the reason for many of the colored shadow effects poetically described by Goethe in his *Theory of Colors* and

re-created in this photograph taken at dusk showing a shadow cast by an object in the path of candlelight. It is tinged with the blue light from the evening sky.

In 1690, Christian Huygens proposed that light moves in waves. Around 1802, Thomas Young did experiments to show that light does indeed move in transverse waves.

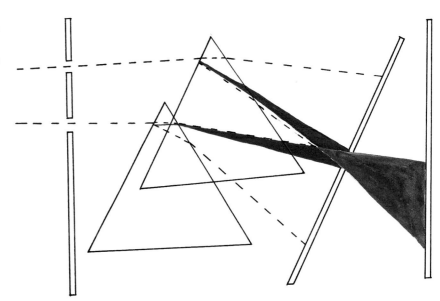

Newton found color's missing link, magenta, which was not available in pigment-color until 1958, with the discovery of the quinacridone dyes.

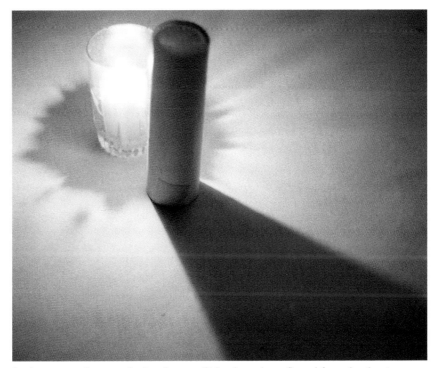

In this set-up photographed under a twilight sky, color reflected from the sky tints the shadow.

Additive Color Mixing: the process of adding light-colors, with a resulting increase in brightness. The colors are mixed when two or more separate colored lights are beamed onto one spot. The resulting color at this spot is the additively mixed light-color. When the three principal light colors, blue, red, and green, are beamed from three separate projectors their additive combination produces white.

Additive mixing of light-colors occurs in vision as the eye registers color, in stage lighting, in the reproduction of color on television and computer screens, and in some sunset color effects.

Subtractive Color Mixing: the process of mixing colors, such as pigments, the combination of which subtracts and thus diminishes light. Subtractive color mixing occurs in art, of course, and in printing, when primary-color inks overlap to produce secondary colors.

Partitive Color Mixing: closely related to additive color mixing, this occurs when dots of different colors are juxtaposed. The resulting color will reflect the same quality of light, as if the colors had been mixed additively. Thus, blue dots adjacent to yellow dots produce the sensation of gray, as illustrated in the reflectance curve on page 76, rather than green mixed subtractively.

Partitive color mixing also occurs in printing and was also utilized by pointillist painters such as Georges Seurat.

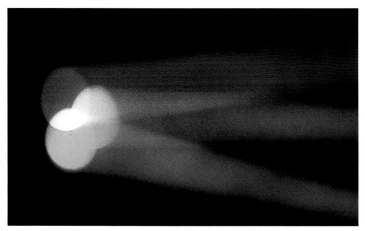

Three additively mixed-light colors: red and green light produce yellow, green and blue produce cyan, and red and blue produce magenta. Photograph reprinted courtesy of Eastman Kodak Company.

Three overlaid transparent Tri-hue sheets—a yellow, cyan, and magenta—illustrate the process of subtracting light as new colors are produced. Courtesy of Richard Nelson.

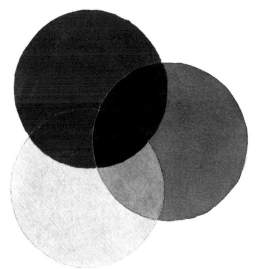

When the equivalent pigment colors are mixed, the subtractive result is black.

LeBlon had discovered and named the three primary hues forming the basis of all trichromatic pigment-color mixing. LeBlon made a further observation: "Mixture of these three original [pigment] colours makes black. . . . a mixture of all the primitive impalpable [light] colours. . . will not produce black, but the very contrary, white."

The distinction between the additive mixing of light-color and the subtractive mixing of pigment-colors is important; too often the two are confused. (See the explanations on page 14.) Both are important to the artist.

In 1777, G. Palmer proposed that there were three retinal receptors (later called *photoreceptors*) tuned to each of three primary light-colors. Physicist Thomas Young first thought the eye would mix the three primary colors of pigments—red, yellow, and blue. However, when he combined a yellow light and a blue light he did not get green but achromatic white! Thus in 1805 Young revised his original hypothesis and named purple, red, and green as the principal light colors to which the supposed three receptors are attuned and from which all other colors that we see are derived.

Proof of the three-receptors theory was undertaken by Hermann G. Grassmann (1809–1877), and Hermann von Helmholtz (1821–1894), as well as Maxwell, each adding to our understanding. Grassmann showed that there are three variables in light-color that must be separately rated. The first of these is *hue*, which is the color. The second is *brightness*, relative to the amount of light reflected. The third is *saturation*, relative to the amount of color present in a stimulus, as compared to white or black. These light-color definitions approximate the three constants of artists' pigment color: hue, value,

and saturation. The boxed text describes the three pigment-color variables that play an important part in our understanding of color in art. We will refer to them constantly.

Helmholtz realized that the three-receptors theory could be explained only on the basis of three fundamental mechanisms with *partially overlapping* ranges, as shown in the graph; otherwise the eye's mixtures of most colored lights would result in white in many cases.

James Clerk Maxwell put both Grassmann's and Helmholtz's observations together to make a conclusive argument for the *trivariance* of human color vision. "The quality of any colour depends . . . on the ratios of the intensities of the three sensations which it excites." The three sensations are, of course, those caused by the simultaneous effect of light-color—containing varied proportions of the three primary colors—upon the eye's three receptors.

Maxwell also concluded that "brightness depends on the sum of these three intensities."[6] The stimulation of the three receptors with the sum of the primaries red, green, and blue is white, and the absence of stimulation is black.

Thus Maxwell provided a definition for obtaining all colors, even dark ones, according to the three variables in different quantities. The process is easy to understand if you think of how we mix pigment colors: three primary colors, when their proportions are adjusted, can make any color imaginable, be it light or dark, saturated or neutral; when mixed together, they make black.

Pot lids made by the English firm Messrs F. & R. Pratt of Fenton around 1850–1860 were printed in color with this engraved plate, which shows the colors that were the forerunners of the primary colors of today's printing technology (magenta, cyan, and yellow).

THE PHYSICAL BASIS FOR COLOR VISION

We now turn to the physiology of color vision. The retina in the eye,

Hue: *the predominant color sensation of perceived color denoted by colors of the spectrum: purple, blue, green, yellow, orange, or red.*

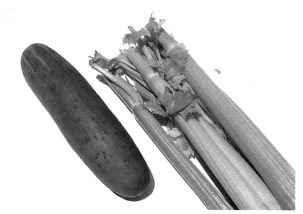

The two different greens of the cucumber and celery provide an example of a hue. That is, they are both of the same hue.

Value: *the relative lightness or darkness perceived from a colored area. In the photo, the cucumber is gauged to be darker in value when compared to the celery, though both have the same hue.*

The lightness of artists' color is not to be confused with the brightness of light-color. For example, a lighted candle can be described as bright when compared to its surroundings. However, a shining candle in a painting can only be portrayed as much lighter than the surrounding area. It cannot be painted brighter than the actual paper.

Saturation: *the amount of color perceived when compared to the amount of white or black. Adjectives to describe degrees of saturation are (A) desaturated, for a light version of a saturated color such as pink; (B) saturated, for vibrant colors such as "Coca-Cola red"; (C) unsaturated, for a less vibrant version of the saturated color; (D) neutral, for a dull version of the saturated color.*

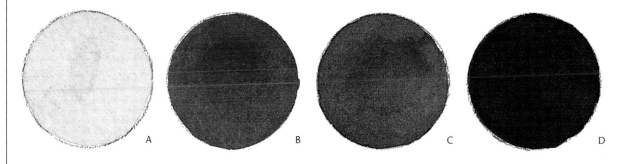

A B C D

The graph shows the ranges of the eye's receptivity for the long red (L), the middle green (M), and the short blue (S) wavelengths, respectively. The broken line shows how both the red (L) and green (S) receptors are engaged when stimulated by red light. From the information collected by the receptors regarding color, the eye makes further calculations for saturation and value at the neural level. Source: Dowling, 1987.

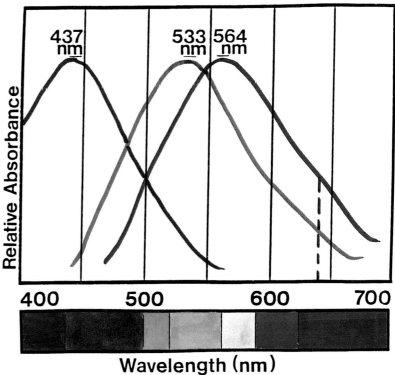

where the colors we see are registered, consists of layers of transparent cells, as shown in the diagram.

Max Johann S. Schultz (1825–1874) realized that there were two systems of receptors contained in the retina: the rod-shaped and the cone-shaped cells, or rods and cones. The human eye contains 100 million rods, mainly on the periphery of the retina. The rods operate under dull lighting conditions, such as when you awaken in the middle of the night and there is not enough light to see color. They are inoperative in daylight or incandescent light. The eye contains 6.5 million cones, many located in the fovea area of the retina. Cones register visual information related to color and operate under incandescent and daylight conditions. Both sets of receptors are connected to the optic nerve by a complex network of nerve cells and synapses.

Within the rods and cones there are *photopigments* that react to light. For example, the rods in the human eye (and in simpler forms of animal life that possess no color vision) contain rhodopsin, a purple photopigment, which bleaches to become yellow when stimulated by light. While in this so-called *fatigued* condition, the organism, unable to register light with a neural response, perceives the opposite, which is darkness. The receptors are unable to react any further to light stimulus until there is a split-second break in stimulation, allowing the rhodopsin to revert to its original purple and again register light and neural responses.

It was assumed that human color vision works in the same way: once photopigments—for instance, iodopsins—are bleached or fatigued by color stimulation, either the absence or opposite of that color, known as the complement, would be the perceived sensation until the photopigment regenerates.

When this happens, the individual is able to see again. Fortunately, among the 6.5 million cones there is plenty of "backup" and so no gaps in vision occur. Although the early theorists believed there were indeed three different photopigments in the human eye's receptors—one for each of the three primary color sensations— it was not until the 1990s that three biological differences in the photopigments were actually distinguished, thus verifying the theories of Grassmann, Helmholtz, and Maxwell.

Once the rods and cones have registered a light-color stimulus, the fine-tuning of color vision takes place at a neural level. The receptor information is sent—via nerve cells in the retina to the visual cortex in the brain—as a signal based on opposites: red or green, yellow or blue, and white or black. As early as 1870, Ewald Hering (1834–1918) had proposed exactly this explanation, but it was in the 1920s that, finally, with the invention of the microelectrode, this was measured and established. Later, television engineers, when designing a system to broadcast color pictures, arrived at a very similar two-tiered method: the scene to be transmitted is first analyzed into three basic color components and then the information is transmitted as two-color difference signals plus a luminance signal.

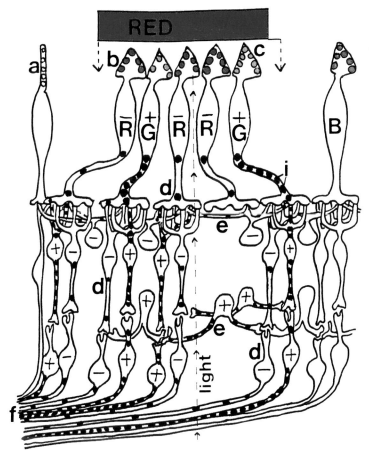

The structure of the retina, showing the on (+) and off (-), or inhibited, visual neurons when the red (R) and green (G) receptors (photoreceptors) are stimulated by red. A rod-shaped receptor for noncolor vision, inoperative when color can be seen, is represented at top left (a). Cone-shaped receptors for color vision are labeled (b) and (c). There are three types of cones absorbing light in the red, green, and blue (B) portions of the spectrum. Nerve cells (d) carry impulses to the optic nerve and communicate with nerve cells (e) leading to nerve fibers (f) that comprise the optic nerve. The black dots (i) represent nerve impulses.

This mechanism results in particularly heightened contrast at borders. In human color vision much greater complexity accounts for contrasts in saturation and hue, as well as value. But the principle of inhibition and disinhibition is identical to the one just illustrated.

Here, simultaneous value contrast, as caused by neural inhibition and disinhibition, is graphically illustrated. Though it's hard to believe, the gray bands are of uniform value. They appear darker at the bottom because the neural response is inhibited by the contiguously placed light area. The bands appear lighter at the top because the neural response is disinhibited by the contiguously placed dark area.

In an instance of simultaneous contrast in human color vision, if two colors such as blue and yellow are juxtaposed, a disinhibition at the boundary of the two makes both colors appear saturated at the same instant. You can see practical examples of simultaneous contrast

at work in the three squares shown at the bottom of the page.

Although experiments starting with those of Hartline and Ratliff demonstrate a physical basis for simultaneous contrast, it should be noted that perhaps the mind is a factor which heightens the effect.

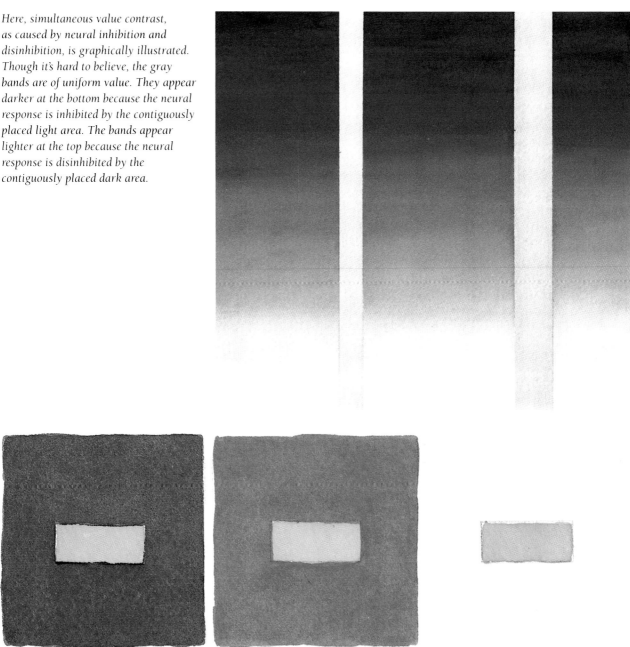

The lime green rectangles inside the squares appear different, first, in saturation; second, in hue; and third, in value, because of the different qualities of the colors surrounding them.

A questionnaire accompanying the bands shown in a horizontal, vertical, and diagonal position showed that a fluted effect was readily perceived in the vertical position—where the image resembles a fluted Greek column—and less so in the other positions.

"Color constancy," noted by Swedish psychologist David Katz, is another aspect of vision in which the mind sees a color such as a white object as constantly white even though under different lighting conditions the color is quite different. You can see how this is so by referring back to the lighthouse photograph on page 10. If you asked one layperson to describe its color at midday and another to describe it in yellow evening light, both answers would probably be "white." For the artist, color constancy is not a major factor, since mostly we portray objects only under one lighting condition and thus key an entire composition to convey the desired color.

Now that we have looked at the physics and physiology of color and related the information to color in art, we will explore how to use, mix, and manipulate color before we progress to creative color use in paintings.

1. Arthur Zajonc, *Catching the Light* (New York: Bantam, 1991). His reference is to Oliver Sacks and Robert Wasserman, "The Case of the Color-Blind Painter," *New York Review of Books* (Nov. 19, 1987), pp. 25-34.
2. Oliver Sacks, "A Neurologist's Notebook," *The New Yorker*, May 10, 1993), pp. 59-73.
3. Peter Gouras, "Measurement of Colour," *The Perception of Colour* (London: Macmillan, 1991), p. 4.
4. Brent Berlin and Paul Kay, *Basic Color Terms* (Berkeley: University of California Press, 1991), p. 2.
5. Quoted in Gouras, "History of Colour Vision," *The Perception of Colour* (Macmillan, 1991), p. 4.
6. Quoted in Gouras, "Measurement of Colour," *The Perception of Colour,* (Macmillan, 1991), p. 11.
7. Goethe, Johann Wolfgang von, *Theory of Colours,* (Yale University Press, 1970), p. 22.
8. M.E. Chevreul, *Principles of Harmony and Contrast of Colors and Their Application to the Arts* (1839), ed. Faber Birren, (West Chester, Penn.: Schiffer Publishing, Ltd., 1987), p. 62.
9. Floyd Ratliff, "Contour and Contrast," *Scientific American,* June 1972.

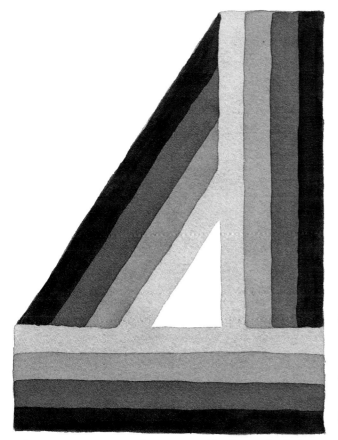

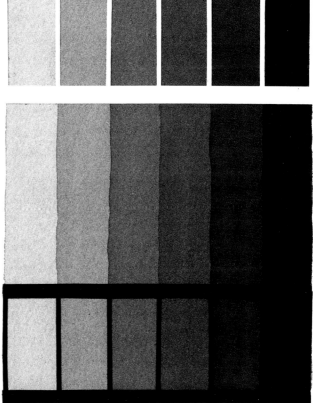

There is an "anticipation factor" caused by the mind, which perhaps contributes the illusion of columnar fluting to the vertical segment of this design.

Artists trained to perceive minute variations in value note that the stripe surrounded by white appears darker than the stripe surrounded by black at the second stripe. Most viewers do not register a difference until the fourth stripe.

KNOWING YOUR COLORS

In this chapter we study color organization systems. We will mix and match colors using a special color map and then prepare a pigment-color wheel as a future guide. We'll compare the pigment-color wheel with the light contrast color wheel, used when gauging how to enhance a color's appearance and when choosing a color scheme. Learning how color perception depends on the quality of adjacent colors—how one color modifies the appearance of another—we'll begin to apply our knowledge to achieve some compositional color effects.

AMARYLLIS '92, 22 × 30" (55.9 × 76.2 cm).

Color Wheels

The wheel structure is used for a systematic arrangement of colors according to the spectrum. There are two categories of color wheels: pigment-color wheels, of which we'll construct two, used for paint recognition and practical color mixing; and the light contrast color wheel, used to find colors that work particularly well together. The pigment-color wheel is based on pigment colors in which opposite color mixtures make black, which is placed in the center. The light contrast color wheel is based on opposite light-colors that when combined make white.

The main observable difference between the two is that with the pigment-color wheel yellow and violet make black and so are placed opposite one another, while in the

contrast color wheel yellow and blue make white and are similarly placed opposite one another. Other colors on each wheel are adjusted to accommodate this basic difference.

Sir Isaac Newton devised the first color circle, the model for subsequent color wheels used today. His circle related to his mixing of light-colors with prisms. Noticing the relationship between the end colors of the spectrum, red and violet, he bent the spectrum to make a circle. Colors he described as "intense and florid in the highest degree"[1] (saturated colors) he placed on the circumference of the circle in unequal divisions, with each color's "best" (maximally saturated) aspect placed halfway between the divisions of the "seven fundamental colours" he had identified in the spectrum.

Although he had discovered colors between spectral red and violet, including what we know as printer's magenta, Newton did not allot an eighth division for it on his circle. He placed white, the additive mixture of all light-colors, in the center, even though he had only been able to make white by combining yellow and blue. Newton's circle was in fact a map used to predict a color's appearance. A color's hue and saturation could be predicted according to its coordinates on the map, 0 being the center and the positions between the maximally saturated colors on the circumference denoted by letters of the alphabet. We will adapt this concept for mixing pigment colors.

The first pigment-color wheel was developed by Moses Harris in his 1766 edition of *The Natural System*

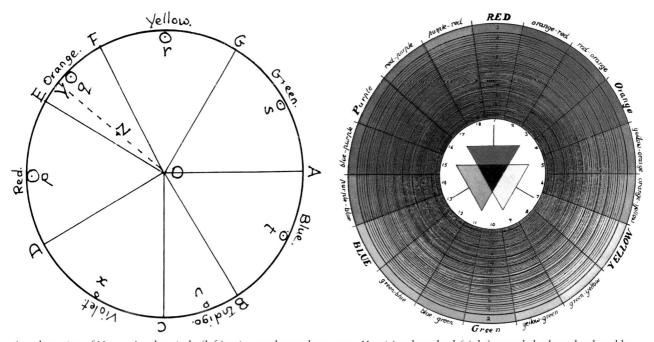

An adaptation of Newton's color circle (left) using modern color names. Harris's color wheel (right) preceded others developed by Goethe and Chevreul, who similarly based the color placement on pigment-colors, whose opposite colors, when mixed, yield black. This reconstructs Moses Harris's 1766 wheel; I have substituted today's permanent rose, peacock blue, and aureolin for the original colors.

1. Quoted in Paul Zelanski and Mary Pat Fisher, *Color,* Prentice-Hall, Inc., 1989.

Here's a simple procedure: Squeeze a very small amount of your first pigment onto the higher portion of a small tilted palette. Pour about a tablespoonful of clean water into your working water container. Make a sample of the paint on sketch paper and write the name of the paint by the sample for reference. Wash the paint off your brush. Then pour the colored water into your "slop jar." Clean the water container and swill the palette with clean water using your brush to remove any paint residue. Again pour the excess water into the "slop jar." Dry your brush and palette, test for cleanliness, and repeat the steps for each pigment.

TRIAL WHEEL

Determine, as accurately as possible, the complement for each color. To do this, mix the colors you consider to be complements to make black or as near to an achromatic gray as possible. If your original choice of color does not make an achromatic gray or black, try another combination. Make notes as you test colors for complements. Draw lines joining the complementary groups on your trial wheel. To determine the placement of a specific paint, decide whether it is warmer or cooler than another, relative to the nearest balanced primary. For instance, Winsor green is nearer in hue to peacock blue than yellow, and thus should be placed nearer to the blue. Paint neutral colors near the center of the circle adjacent to the saturated color they resemble.

Now you are ready to draw your basic wheel structure in pencil and make individual circles, appropriately placed, for each color.

MAKING YOUR WHEEL

Using a 3B sharp pencil, draw a circle on your paper, then the corners of an equilateral triangle. Next add four small circles with a template for the main colors. Instead of three balanced primaries, I prefer permanent blue ultramarine and Winsor green, together with permanent rose quinacridone and aureolin yellow cobalt. Finally, fit in all the colors you own, overlapping some because of space constraints. You may want to make extra circles for colors you think you will buy in the future. Make several photocopies of the circle on Arches 90-lb. paper for both this lesson and the next.

Using your trial wheel as a guide, paint the colors in the circles. Start with your most important primary colors, then work in color groups.

INDICATING LIGHTFASTNESS

To make a color lighter on the inside to indicate lightfast colors, prewet the circle and lay in the darker color on the outside and help the color blend to form the lighter center. Lift off the center with an almost-dry brush. The colors that are lightfast only when applied in heavy application are painted with solid color. (Depending on the number of colors you have, this can take a long time.)

Protect your pigment-color wheel by placing it on a mat board of the same size and then sheathing it with plastic. It will be a valuable tool.

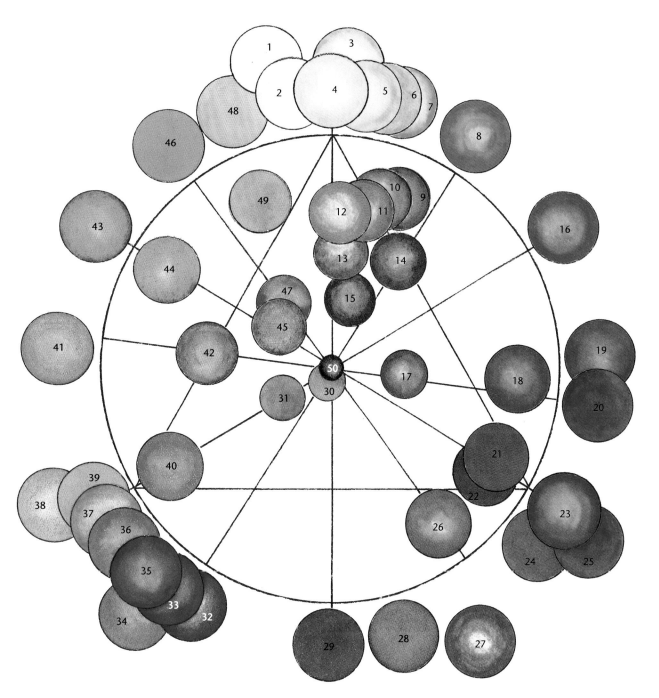

1. Winsor yellow (W&N)
2. Cadmium yellow lemon (Holbein) *
3. Aureolin yellow monoazo (Holbein) or Hansa yellow *
4. Aureolin yellow cobalt (W&N) *
5. Cadmium yellow pale (W&N)
6. New gamboge
7. Cadmium yellow (W&N)
8. Cadmium orange (Grumbacher)
9. Quinacridone burnt orange (D. Smith) +
10. Quinacridone gold (D. Smith) +
11. Raw sienna (W&N) +
12. Yellow ochre (W&N) *
13. Raw umber
14. Burnt sienna (W&N) *
15. Burnt umber (W&N)
16. Cadmium orange-red (Blockx)
17. Indian red (W&N) +

18. Cadmium red deep (W&N) *
19. Cadmium red (W&N) *
20. Winsor red
21. Alizarin crimson (W&N) *
22. Crimson lake
23. Permanent rose quinacridone (W&N) *
24. Rose madder genuine (W&N) +
25. Opera (Holbein) +
26. Magenta (W&N) +
27. Cobalt violet (Rowney or Da Vinci) *
28. Permanent mauve (Rowney)
29. Thalo purple
30. Payne's gray (W&N)
31. Indigo (W&N)
32. Ultramarine blue deep (Holbein) +
33. French ultramarine blue (W&N)
34. Cobalt blue (W&N) *
35. Permanent blue ultramarine (W&N) *

36. Winsor blue (W&N) *
37. Cerulean blue (Rowney) *
38. Manganese blue (W&N) +
39. Peacock blue (Holbein)
40. Prussian blue (W&N)
41. Cobalt turquoise (W&N) +
42. Prussian green (W&N)
43. Winsor green (W&N) *
44. Viridian green (W&N) +
45. Terre verte (W&N)
46. Hooker's green
47. Oxide of chromium (W&N) +
48. Permanent green no. 1 (Holbein)
49. Sap green
50. Ivory black (W&N) +

* Minimum colors needed
+ Paints with unique color or qualities

Lack of dominance in at least one category makes for a color scheme that lacks order and relays an unfocused message. Too much color can be boring. Here is where color contrast comes into play. The greatest contrast of hue is between complementary colors. By including the dominant color's complement you not only forestall boredom but you actually emphasize the dominant color by eliciting a simultaneous contrast reaction in the way the eye perceives color.

In conclusion, be careful not to fall into the "safe" color-scheme trap. Predictable schemes, especially complementary ones, will soon bore the viewer. Imaginative, original color used to convey an idea will endure.

TAMMY, 22 × 30" (55.9 × 76.2 cm).

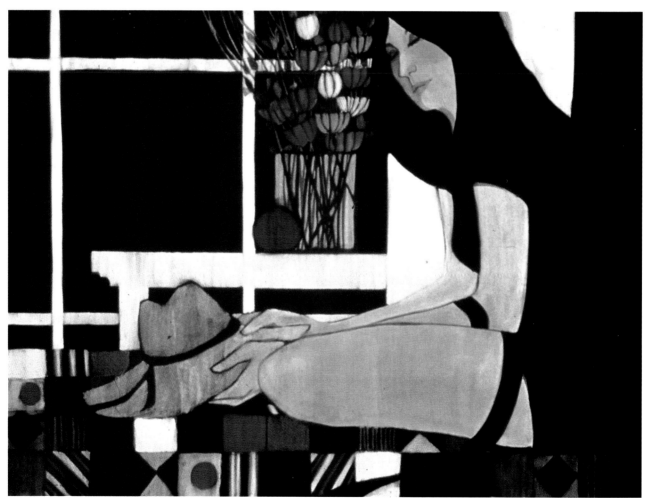

Polly Hammett, **QUILT SERIES: THE STRAW HAT,** 22 × 30" (55.9 × 76.2 cm). Collection of Mr. and Mrs. W.M. Carl.

The artist uses black as a color to emphasize design and middle-valued colors, of which there are very few.

LESSON 2 *Optical Color Modifications*

Now that you've made your color wheels, you may be thinking, "Now I know what color is all about!" But color holds some surprises. Contrary to appearances, color, even when viewed under identical lighting conditions, is not absolute, but relative: the eye assesses and differentiates one color from another by comparing. As a result, colors appear to change according to the juxtaposition of one to another.

There are two categories of color modification: simultaneous contrast and successive contrast. They occur because of different mechanisms in the visual apparatus, as described in the first chapter. We will study both phenomena and make sample sheets of color modifications. Note that many modifications rely on minute nuances of color differences. Because of the limitations of the printing process the effects may not show up clearly in the illustrations. Thus you should actually work through these and all the practical exercises so you can more readily see the color effects described with true pigment color. You will learn much more about contrast by painting to produce effects than by just cursorily glancing at the illustrations.

There are great differences in people's ability to see subtle nuances. Artists' eyes seem to be more fine-tuned than the layperson's. Squinting as you gauge colors will help you to see the differences.

Both categories of contrast play a role in determining how a color appears and thus must be considered in all your uses of color.

SIMULTANEOUS CONTRAST

The instantaneous modification of one color by its contiguous color is *simultaneous contrast*. This occurs because the eye assesses a color by comparison with its surroundings in a process of inhibition and disinhibition and of on-and-off encoding in the nerve cells of the retina and visual cortex of the brain.

Our study covers various simultaneous contrast effects, including the modification of a color's value, saturation, and hue, and the eye's tendency to jump to conclusions about a color's appearance. We'll follow this with examination of successive contrast effects and end with studying how we can manipulate color placement in a composition to evoke a desired effect.

DEMONSTRATION SIMULTANEOUS COLOR MODIFICATIONS

COLOR LESSON: Modifying a color's value, hue, and saturation.

AIM: To make a simultaneous modification sheet of value, saturation, and hue

SEEING: The phenomena of various contrast effects

DRAWING: Structures for color modification exercises

PAPER: 11 × 14" sheets of 140-lb. Arches cold-pressed; white paper

BRUSHES: 1/2" flat, #6 round

COLORS: Your panoply of paints

ALSO: Pigment and contrast wheels, T-square, HB or 3B sharp pencil, single-edge blade, three water containers, palettes

DRAWING

With your 11 × 14" sheet of paper laid horizontally, use a T-square to draw 2" pencil-line squares as shown. The top horizontal and the left-hand vertical lines need to be slightly separated from the other group of three lines. Cut a template for the central squares and rectangles so you can quickly trace in, with light pencil lines, the centers of all the 2" squares.

PAINTING

Making a point on your #6 brush, paint the inner squares first to be sure they are identical. Then with your 1/2" brush, paint the surrounding colors to cause the eye to modify the inner color. To prevent smudging, be sure one area is dry before you paint another; also rest your painting hand on a tissue and not on your paper. Wash your palette and brush thoroughly between each paint application, and dry them with a white tissue to detect any residual paint.

I first painted the gray square centers in row 4 and also the rectangular centers of A2 and A1. I used diluted lamp black to make a gray and I mixed more than enough so I didn't run out before completing the series. I next painted the lemon yellow centers. The yellow centers to be surrounded by black, purple, and blue must be next to one another as shown. I continued to paint three identical inner horizontal colors in an array of saturated colors.

For the surrounding colors it is easier and neater to start with the top row. The yellows are surrounded by black and purple, respectively, and one gray is surrounded by black.

For the surrounding colors in rows 4 and 3, I consulted my contrast color wheel to find the complement that will elicit the optimum contrast effect. I then painted pairs of surrounding colors as shown. For the remaining squares I consulted my pigment color wheel. Those in row 2 are chosen because they are on the cooler side of the color and thus will make the inner, influenced color appear warmer. The surrounding colors in row 1 are picked because they are

of color, such as the dark purple amid the mass of yellow and white. Thus, areas of contrast will tend to be the focal point of a painting and need to be suitably placed in the overall composition.

- Because of the "jumping" aspect of vision you can achieve unity by repeating a color outside the main block (4). The color distribution is not so effective if color is not repeated.
- Blocks of color such as the green block (4), when not repeated and placed in peripheral positions, can make a composition dissatisfying.
- Although colored patterns (4) attract the eye, partitive color mixing diminishes overall saturation.
- If pattern colors are complementary or contrasting, the overall effect of saturation will be reduced. If there are two colors that are analogous or similar, the colors will combine optically. The saturation is measured as an average between the two.
- The shapes of areas of the same value or color need to be related and interesting, unlike the rose and green masses (4), which are rather boring blocks.
- Look at the black and white circle and at (2). Light areas tend to expand, especially when surrounded by hard-edged, dark, contrasting colors.
- Look at the black circle surrounded by white and at (3). Dark areas tend to appear reduced in size, especially when surrounded by hard-edged light colors.

Now we'll put your knowledge of matching and mixing colors and of contrast colors and composition to practical use with a subject of brightly packaged groceries. We'll also take a first look at shadow colors.

Following this lesson, you will have a foundation of theoretical color information and be ready to move on to an examination of practical aspects of pigment-color.

DEMONSTRATION
SNACKS FOR ALL

COLOR LESSON: Mixing, matching colors; manipulating color to create compositional effects

CONCEPT: Brightly colored composition

SEEING: Grouping the colors to make a composition

DRAWING: Direct drawing with paint

COLORS: The colors you own

PAPER: 1/4 sheet of 140-lb. Arches cold-pressed

PAPER: 1/2" flat, #6 round, #3 rigger

ALSO: Visualizing mat with a crossed-thread grid, of the same proportion as your watercolor paper; Art Gum eraser, tissues, three water containers

COMPOSITION

Using what you have learned from the colored square arrangements, group your groceries according to color in an attractive, balanced composition on a white surface with a white background. Illuminate the set-up with indirect daylight or fluorescent lighting.

OBJECTIVE COLOR

Even on an indirectly lit subject such as this, there will be some shadows. Here the shadows are a duller version of the saturated color. Many painters, especially those working from photographs, use a Payne's gray glaze for the shadow; the result is lifeless color. Instead, mix the gray from aureolin yellow cobalt, permanent rose, and permanent blue. By adding more of one color than another you can make a chromatic gray to reflect

the color of the object, as I did in this grocery painting.

COLOR THEORY

By grouping objects according to color, you will make a much more powerful color statement than if individual colors are dotted around the composition. Repeating color groups unifies a composition. In my set-up the blues flow from left to right. The yellows are repeated frequently outside the yellow group. The mauve and green groups have a little of each color outside the group, too. This follows the abstract guides we studied in the square arrangements.

DRAWING

Try to paint direct without a pencil guide, to stay focused on color. Use a visualizing mat with a crossed-thread grid to aid placement and proportion. Rather than making a cross grid on your paper to match the crossed threads, make a dot for the center and mark the halfway point of each side. Then, imagining the grid, place your objects as you paint, using the center point as a guide. If you really feel lost without a pencil guide, make a drawing on sketch paper and transfer it using a light box or window. My demonstration is painted direct.

PALETTES

Palette 1: Yellows, browns and orange. *Palette 2:* Blues. *Palette 3:* Greens. *Palette 4:* Reds and mauve. *Palette 5:* Grays. The colors are aureolin yellow cobalt (S), permanent rose quinacridone (S), permanent blue ultramarine (S).

This demonstration is unusual, since we will use a large quantity of different tube paints. Rather than name each paint, I have divided the palettes according to color.

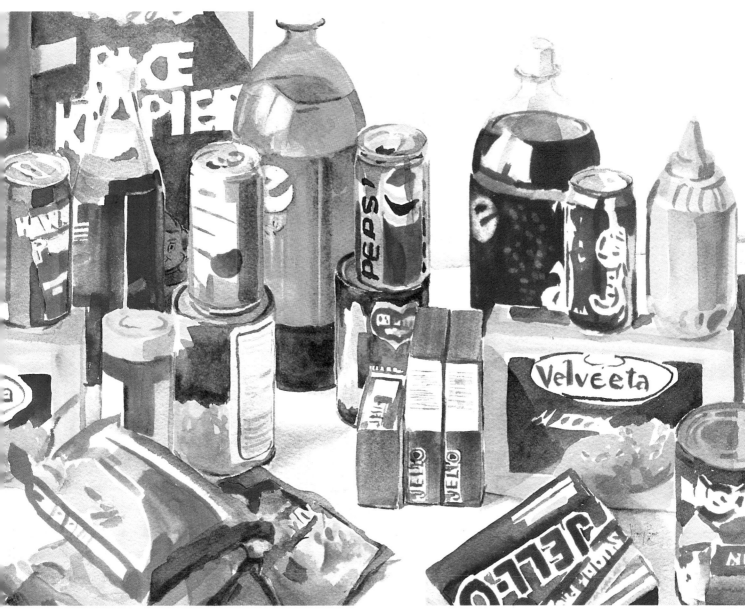

Using the visualizing mat, note what appears at the center point. On a scrap of watercolor paper, make a test swatch of the paint you think matches as nearly as possible the saturated color of an object near the center of the composition. Hold the sample up to the object. If you don't have the tube paint, mix the color. Now start painting, working from the center of the composition. Make sure the first object is correctly proportioned for the size of the composition and paper.

As you add objects, continually check colors and the proportion of objects. Paint only saturated colors. Dry your painting. Using the three primary colors, mix a neutral gray. Then, according to the saturated color of the object, add a touch of that color to the gray for the shadow color. Make the shadow colors bold and resolute. If your painting doesn't work out quite as planned, remember that one purpose is color matching and recognition. If you achieve that, then the lesson has been successful.

KNOWING YOUR PIGMENTS

As artists we contend not just with observed color but also with pigments and their unique properties. In this chapter we survey various aspects of pigments. We first define the difference between pigment and paint. After a brief look at paint and pigment history and nomenclature, we consider the compositions of pigments, along with tests for their handling characteristics and lightfastness. Finally, we cover spectral reflectance curves and how to read them.

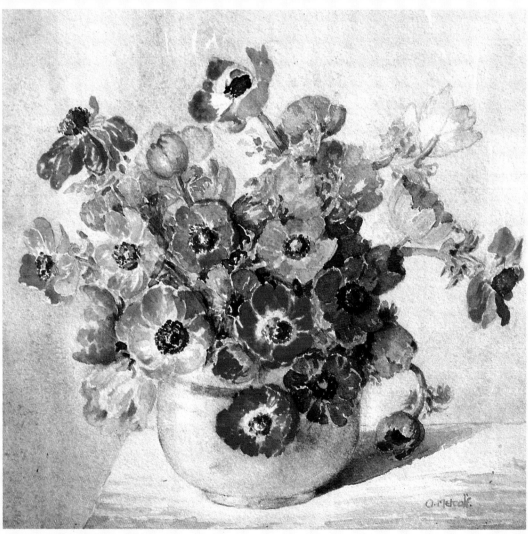

Ann Metcalf, **ANEMONES**, 26 × 22" (66 × 55.9 cm).

Painted in 1954 and exposed to normal lighting conditions, this watercolor's dominant pigment, Winsor red, has proven quite lightfast.

LESSON 1 *History, Nomenclature, and Categories*

Pigments are microscopic insoluble chemicals that, when viewed under incident white light, reflect specific colors (wavelengths of light) as they absorb others. Pigment-color mixing operates under the laws of subtractive color mixing, as described in the first chapter.

To be useful to the artist, pigments are manufactured into paint. They are prepared and ground, then suspended or dispersed in a vehicle such as linseed oil for oil paints, or an aqueous vehicle such as gum arabic for watercolor paints, enabling the pigment to adhere to a surface.

Watercolor paint, the medium used for the demonstrations in this book, also contains a wetting agent such as ox-gall to help the paint flow, a moisturizer such as glycerin or honey, and a preservative to prevent mold. When paint is applied, the pigment is left attached to the paper as the fluid evaporates.

Such convenience is far removed from paintmaking procedures prior to the 18th century. Artists' apprentices grated and mixed with water barely soluble lumps of pigment and gum arabic and formed cakes of color that then had to be grated again before being ready for the artist's use. Three events led to the improvement of watercolor paint. First was the addition of moisturizing honey to gum arabic to make watercolor much easier to use. This was accidentally discovered by William Reeves of the Reeves Paint Company, founded in 1776. Second was Henry Newton's development of paint moistened with glycerin that he put into pans; at the touch of a moist brush, the paints were soluble. Third was the invention of the first

collapsible metal paint tube by the American artist John Goffe Rand, who was working in London at the time. Henry Newton, in partnership with William Winsor, bought the patent for the tube in 1842 and subsequently began manufacturing paints in tubes.

GENERAL PIGMENT HISTORY

Before 1800, pigments were limited to the earth colors used since antiquity and the medieval organic range of colors, which were expensive or fugitive (having a tendency to fade). The synthesizing of mineral salts led to the development from 1800 to 1910 of inorganic pigments still used today, such as the cobalts, cadmiums, synthetic ultramarine and chromium colors. William Perkins's 1856 use of "coal tar" to produce a synthetic dye led to the development of hundreds of synthetic organic dyes derived from hydrocarbons.

Grouped by general molecular arrangement, the major categories include phthalocyanine (1907); azo, which includes naphthols and arylides (1900); dioxazine (1952); and quinacridone (1958), derived from phthalocyanine. The discovery of synthetic organic "dye" pigments continues to this day as paints are continually improved in both handling and lightfast qualities.

NOMENCLATURE

Paint names are particularly confusing because there has been no common naming system among companies. Paints with the same chemical composition have different names, such as phthalocyanine blue, which is called Monestial, Winsor,

Thalo, Blockx, and Mineral Blue (Sennelier), to name but a few. However, each manufacturer's blue is slightly different, so I suppose the name difference does serve in hue identification.

Other paints have the same name but different chemical composition. For instance, aureolin, named and first put on the market by Winsor & Newton, is potassium cobalt nitrite, as are the Rowney, Blockx, and Daniel Smith aureolins. But Holbein's and Sennelier's aureolins consist mainly of an arylide pigment, which is less expensive and has different handling qualities.

Permanent rose is even more confusing. Permanent rose quinacridone (PV19) as manufactured by Winsor & Newton and Rowney is the permanent version of rose, as in rose madder genuine. Blockx calls this magenta, and Grumbacher calls it Thalo red or Thalo crimson. On the other hand, Holbein's permanent rose is not quinacridone at all but, instead, Disazo lake, which is fugitive and not a very good color mixer. Holbein's paint called Opera, however, is composed of quinacridone!

Many of the old pigments such as Indian yellow, made from the urine of water-deprived, mango-fed cows, are not used anymore—in this case because of the cruelty involved in its manufacture. However, the name persists even though the pigment is now a form of arylide, as are all the gamboge paints whether they are called gamboge, gamboge hue or new gamboge (as opposed to the old fugitive gamboge genuine). Hansa yellow, too, an old trade name for the German Hoechst company, is an arylide.

Companies in the past prefixed a name with "permanent" to distinguish it from its fugitive namesakes.

The American Society for Testing and Materials (ASTM) has attempted to clarify nomenclature. It requires manufacturers to print on the paint tube label the common name and the color index name. Permanent rose, for example, is Pigment Violet 19 (PV19) and Color Index Number 46500. (The five-digit index number describes the chemical constitution of the colorant. See the tables that follow.) However, it is important to note that these specifications do not indicate purity, quality, or concentration, and that even the color reference is very general. The ASTM also requires companies to suffix a name with the word "hue" if the paint does not contain the chemical implied in the name—for example, gamboge

NATURAL INORGANIC PIGMENTS

(Winsor & Newton, unless stated otherwise)

Raw sienna	*PY43, 77492*	*Natural iron oxide*
Burnt sienna	*PBr7, 77491*	*Calcined (roasted) natural iron oxide*
Raw umber	*PBr7, 77491*	*Natural iron oxide and manganese dioxide*
Burnt umber	*PBr7, 77491*	*Calcined natural iron oxide and manganese dioxide*
Yellow ochre	*PY43, 77492*	*Native earth containing hydrated ferric oxide*
Terre verte	*PG23, 77009*	*Natural earth with ferric and ferrous oxides*
	+PG18, 77289	*Hydrated chromium sesquioxide*
Indian red	*PR102, 77491*	*Listed as natural iron oxide*

SYNTHETIC INORGANIC PIGMENTS

(Winsor & Newton, unless stated otherwise)

Aureolin yellow cobalt	*PY40, 77357*	*Potassium cobalt nitrite*
Cadmium red	*PR108, 77202*	*Cadmium sulphoselenide*
Cadmium orange (Grumbacher)	*PO20, 77202*	*Cadmium sulphoselenide*
	+PR108:1, 77202:1	*Concentrated cadmium sulphoselenide and cadmium selenosulphide coprecipitated with barium sulphide*
Cadmium yellow	*PY37, 77199*	*Cadmium sulphide*
Cadmium yellow lemon (Holbein)	*PY37, 77199*	*Cadmium sulphide*
Cerulean blue	*PB35, 77368*	*Cobalt/tin oxide*
Cobalt blue	*PB28, 77346*	*Cobalt/aluminum oxide*
Cobalt turquoise	*PB36, 77343*	*Cobalt, aluminum, chromium oxide*
Cobalt violet	*PV14, 77360*	*Cobalt phosphate*
French ultramarine blue	*PB29, 77007*	*Complex of sodium alumino-silicate with sulphur*
Manganese blue	*PB33, 77112*	*Barium manganate*
Oxide of chromium	*PG17, 77288*	*Anhydrous chromium sesquioxide*
Permanent blue	*PB29, 77007*	*Complex of alumino-silicate*
Ultramarine deep (Holbein)	*PB29, 77007*	*Complex of sodium alumino-silicate with sulphur*
Venetian red	*PR101, 77491*	*Synthetic iron oxide*
	+PBr7, 77491	*Natural iron oxide*
Viridian	*PG18, 77284*	*Hydrated chromium sesquioxide*

hue differentiates the paint from gamboge genuine.

While nomenclature is certainly confusing, there is plenty of available information to which you can refer. You can write to the manufacturer whose address is printed on the paint label for information, as I did for the tables that follow. I personally enjoy the haphazard paint names. They add an element of tradition and nostalgia absent from uniform names and numbers. How prosaic it would be if viridian were called hydrated chromium oxide, or if sepia, indigo, and carmine were dropped from the list. We're artists, not scientists!

PIGMENT CATEGORIES

To a large extent the chemical composition of a pigment will give you some indication as to how the paint will handle when applied, how lightfast it is, and what type of color to expect.

Manufactured pigments fall into two main categories. These are *inorganic*—rocks and some elements, excluding carbon—and *organic*—predominantly hydrocarbons. These major categories can each be further divided into natural and synthetic subcategories, making four classifications in all: *natural inorganic, synthetic inorganic, natural organic,* and *synthetic organic.*

These are listed below, along with colors falling into more than one category. These are the colors I use, thus I do indicate brand names where applicable. Examining these pigment groups will help you become familiar with the characteristics of each.

NATURAL INORGANIC PIGMENTS

Natural inorganic, or "earth" pigments, occur naturally in the environment as clay with a high iron content. Generally, earth pigments are neutral in hue and have a granular quality, and most will not lift when rewetted and wiped. Most are extremely resistant to fading, or lightfast. They mostly settle when applied wet-on-wet and do not creep uncontrollably, but their clay content makes them tend to dry out a little and produce an "ozzle" (an inward-moving watermark).

SYNTHETIC INORGANIC PIGMENTS

Synthetic inorganic pigments have just a few common characteristics because their chemical composition is so varied. They are usually quite brightly colored, contain sediment, and are lightfast. Today's synthetic inorganic pigments are produced by chemical interaction—occasionally by matching the chemical composition of the original material, as in the case of ultramarine. Most often they are manufactured from metallic elements discovered during the 19th century. As such, many are toxic, particularly the cobalts and cadmiums; they should not be ingested.

SYNTHETIC ORGANIC PIGMENTS

Synthetic organic pigments are often referred to as "dye" pigments. This is a misnomer, for pigments are not dyes. Dye has to be "fixed" onto a white or transparent inert pigment such as alumina hydrate to transform it from soluble dye to insoluble pigment. Synthetic organic pigments are derived from hydrocarbons such as "coal tar" and benzine. General characteristics of these pigments are that they are intensely colored, transparent, and *staining,* so usually they will not lift when once applied. This makes them ideal for transparent glazing, since the original washes will not be disturbed by subsequent overlays. They are also of a relatively smooth consistency, though this can vary. Most synthetic organic pigments are not as lightfast as the inorganic pigments.

NATURAL ORGANIC PIGMENTS AND COMPOSITE PAINTS

There are so few stable natural organic pigments that, in fact, they can be learned with the synthetic organic paints. They are generally transparent with a small amount of sediment. They lift readily from the paper when it is rewetted, and they work well for "direct" painting. They do not spread uncontrollably when applied wet-on-wet. Of the few natural organic pigments still available, only two are lightfast, though rose madder genuine became slightly violet in my own test. These are very user-friendly pigments.

Of the others presently available—Van Dyck brown, gamboge genuine, and carmine genuine—the colors are exquisite, but they are fugitive: after a few years or so, depending on conditions, they will probably show signs of fading.

The names of former natural organic pigments have been retained—sepia, sap green, Indian yellow, indigo, rose madder (alizarin)—but manufacturers have changed the chemical composition either because of difficulty in obtaining the original or to provide more lightfast pigments.

If your painting requires an area of uniform color, then these composite paints can be useful. Otherwise, they can be mixed from the listed colors. A color nearly matching permanent green no. 1 can be mixed from cadmium yellow lemon and Winsor green.

SYNTHETIC ORGANIC PIGMENTS

(Winsor & Newton, unless stated otherwise)

Alizarin crimson	PR83, 58000	1,2 Di-hydroxyanthraquinone
Aureolin (Holbein)	PY3, 11710	Monoazo pigment
	+PY43, 77492	Hydrous iron oxide
Hansa yellow (Daniel Smith)	PY97, 11767	Arylide yellow FGL
New gamboge	PY1, 11680	Arylamide yellow
	+PR3, 12120	Toluidine red
Gamboge hue (Rowney)	PY3, 11710	Arylamide yellow
	+PY153, n/a	Nickel dioxine yellow
Quinacridone gold (D. Smith)	PO49, 73900	Quinacridone
Indigo (Grumbacher)	VatB1, 73000	Anthraquinone
Lamp black	PBk6, 77266	Carbon black
Opera (Holbein)	Basic Violet 10, 45170	Fluorescent pigment
	+PR122, 73915	Quinacridone red
Peacock blue	PB17, 74200	Trisulphonated copper phthalocyanine
Permanent rose/magenta	PV19, 46500	Quinacridone violet
Permanent mauve (Rowney)	PV23, 51319	Dioxazine
	PR122, 73915	Quinacridone
Prussian blue	PB27, 77510	Alkali ferriferrocyanide
Thalo purple (Grumbacher)	PV23, 51319	Carbizole dioxazine violet
	+PV15, 77007	"Ultramarine," complex silicate of sodium, aluminum with sulphur
Winsor (phthalo) blue	PB15, 74160	Copper phthalocyanine
Winsor (phthalo) green	PG7, 74260	Chlorinated copper phthalocyanine
Winsor red	PR2, 12310	BON arylamide
Winsor yellow	PY1, 11680	Arylamide

NATURAL ORGANIC BASE PIGMENTS

(Winsor & Newton)

Rose madder genuine	Natural Red 9, 75330	Prepared from madder root
Ivory black	PB6, 77267	Obtained by calcination of bones

COMPOSITE PAINTS

When you see the paints of these colors, you may decide you can mix them rather than buy them separately.

Sepia	PBr7, 77491	(Burnt sienna) calcined natural iron oxide
	+PBk6, 77266	(Lamp black) carbon
Indigo	PR83, 58000	Alizarin lake
	+PBk6, 77266	(Lamp black) carbon
	PB15, 74160	Phthalocyanine
Payne's gray	PR83, 58000	Alizarin lake
	+PBk6, 77266	(Lamp black) carbon
	+PB27, 77510	(Prussian blue)
		Alkali ferriferrocyanide
	PB29, 77007	(Ultramarine)
Permanent green no. 1 (Holbein)	PG7, 74260	Polychloro copper phthalocyanine
	+PY53, 77788	Nickel-antimony titanate
	+PY1, 11680	Monoazo

LESSON 2 *Testing Pigments for Handling*

Each pigment, even within the same category, handles differently when applied to identical watercolor paper. To know how your transparent watercolor paint handles and to have a record for reference, you need to make your own color test for every tube of paint you own. So before you collect too many different paints start testing now! Then test each new color you buy as you add to your collection.

The tests should be performed on the watercolor paper you use most frequently. I recommend using a 90-lb. Arches cold-pressed paper; a "rough" paper surface is too pitted for some tests and the 90-lb. paper

will permit you to photocopy your initial drawing.

Our test covers clarity of color, tinting strength related to the quality or purity of the pigment, value range, degree of opacity, consistency related to the degree of sediment, how the paint handles when applied wet-on-wet, and whether it stains or lifts off the paper when rewetted and wiped with a tissue.

PALETTE

You'll only need one palette. Use the same procedure for cleaning your palette and brush as described on page 26, where you painted your color wheel.

DEMONSTRATION
PAINT HANDLING TESTS

COLOR LESSON: Comparison of paints

AIM: To create a reference file on how each tube of paint behaves

SEEING: Noting different pigment characteristics

DRAWING: Test boxes

COLORS: All the tubes of paint you own

PAPER: 8½ × 11" 90-lb. Arches cold-pressed (will go through a photocopier)

BRUSHES: ½" and 1" flat

ALSO: White tissues, three water containers, T-square, loose-leaf folder, 8½ × 11" plastic page protectors, magnifying glass

TEST SHEETS

In pencil, use your T-square to draw out four pairs of squares on 8½ × 11" sheets. Leave about ⅛ inch between each square. Arrange them at the right-hand side of your paper: the graduated wash tests should be on the far right side of the paper and the wet-on-wet tests on the inside. Leave enough at the left-hand side of the pairs for identification and notes. Divide the outside graded-wash squares into two. Make a dark pencil line on the inside rectangle from top to bottom to test the degree of opacity. Inside the second square, make a 1" square to test the pigment for wet-on-wet behavior. Draw out lines on the left as shown for the common name and identification numbers (see illustration).

WET-ON-WET

With the paper flat, use your 1" brush to wet the total area of a pair of 2" squares. For the wet-on-wet test, make sure the paper has an even shine but no puddles. Using your ½" flat brush loaded with reasonably thick paint, paint within the boundaries of the inner square. Do not move your paper until the shine has gone. Make notes as to how the paint acts. Does it settle within the square, spread wildly, halo, or "ozzle"? With a magnifying glass, look at the separated pigment and evaluate its textural quality. Does it show sediment or is it fine?

The second square should still be wet. Starting at the top, and with thick paint almost straight from the tube on your ½" flat brush, lay in and then draw down the paint, gradually weakening the wash. Leave to dry at least 24 hours before completing the handling tests.

Ultramarine Violet
(Daniel Smith)
PV 15 77007
- granular, lifts,
spreads, oozles.

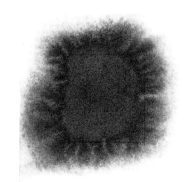

MAKING NOTES

Make notes as to how the paint appears. Is the color saturated or neutral? Is the tinting strength of the color strong or weak? What are the darkest values the pigment is capable of producing on a range of 0–10, counting zero as lightest value? Does it wash out evenly or does it leave brushmarks? Both have their uses. Does the paint contain sediment or is it finely ground?

Check the pencil line and see whether or not it is visible no matter how heavily the paint is applied (see illustration). The same dark-valued pigment may be nontransparent at full strength but transparent in a weak wash. The paint can be considered relatively opaque if the pencil line is hidden in the middle to darker values.

LIFTING TEST

Now test for lifting quality. When the paint is thoroughly dry, wet your ¹/₂" flat brush. Brush the paper on the side with the pencil line with five brushstrokes. With a clean, dry tissue, wipe off the paint with one strong, decisive action lifting from dark to light portions. Make a note of whether the paint lifts off or stains the paper. Your final result will resemble the violet sample here.

LIGHTFASTNESS

If you want to do your own lightfast test, cut about a ⁵/₈" paint strip from the far right of your paint sample, making strips of four. Mark the date on the back of each group for reference. Place the main portion of your test sample in the plastic page protector and put them in a folder. These will be your control samples and as such should be stored in a dark place until the lightfast test is complete. (See appendix.)

LIGHTFASTNESS

Lightfast describes a pigment that resists fading or color change over a specific period of time when exposed to light under indoor lighting conditions, where a painting is normally exposed. Fugitive describes a pigment that, under the same conditions, fades over a relatively short period of time. When paints were first manufactured commercially, individual manufacturers undertook their own lightfast tests. Following the introduction of synthetic organic pigments derived from "coal tar" after 1868, many other colors were synthesized which proved to be fugitive.

In 1907, in an effort to set some standard of lightfastness, artists and representatives of the color industry agreed that a good-quality dark alizarin crimson was to be used as the minimum standard of lightfastness from which to measure new pigments introduced into the market. Today alizarin is considered only marginally lightfast, such is the improvement of modern synthetic organic pigments over the old ones. The Blue Wool Reference Scale (consisting of a horizontal band of eight narrow strips of fabric each dyed to fade at a constant, progressively slower rate) was later also adopted by manufacturers as a measuring standard.[1] Recently, the American Society for Testing and Materials has set more stringent standards; in 1983 ASTM introduced "Test Methods for Lightfastness of Pigments Used in Artists' Paints."

The great variation among manufacturers' claims about the actual time a pigment will resist fading is due to many variables affecting pigments, such as quality of the paper and framing, thickness of the paint application, sensitivity of the pigment to atmospheric conditions—heat, alkalinity/acidity, and humidity.

While most artists' paints are of fine lightfast quality, there are a few that are not and the ASTM has performed a service in setting the standard. Most companies as a result are much more cognizant of lightfastness than previously, although a few unmarked, unstable paints slip through the cracks.

1. ISO Blue Wool Cards Standard 3 used for lightfastness testing are available from: Golden Artists Materials (phone 1-800-959-6543) or from Talas, Division Technical Library Service, 213 West 36th Street, New York, New York 10001-1996.

LESSON 3 *Spectral Reflectance Curves*

A spectral reflectance curve is a graph showing the percentage of incident light reflected from a pigment-colored surface at each wavelength. A spectrophotometer is used to measure the light and plot the graphs. Reflectance curves for over forty pigments are included in this book. Each curve shows the graph, a spectral band of color showing the general color at each wavelength for easy reading, and a sample of the actual color below the graph.

The black portion in the graph above the curves represents the amount of light *absorbed* by a surface. The light portion below the curve shows the percentage of incident light *reflected* at each wavelength. An increasing area of black in the curve denotes an increasingly dark-colored surface. (See illustrations.)

White paper reflects nearly 90 percent of the incident light. Thus you can conclude that the greater the amount of white in a curve, the proportionately lighter in value the colored surface. Changes in the intensity of light do not significantly change the general shape of the color's curve, measured from the lowest point on the graph at which the curve begins and extending above the straight band of white light.

Here are some pointers to help you read the spectral reflectance curves in later chapters on the colors: Primary colors, especially balanced primaries—aureolin, peacock blue, and permanent rose—have wide curves because they reflect over a broad portion of the spectrum, indicating extensive potential for mixing other colors.

The shape of the curve for "printer's magenta"—permanent rose in watercolor—is not included in the spectrum, and so the curve peaks in both the red and blue wavelengths. The curves for nonprimary, saturated pigment-colors—greens, purples, and reds—are relatively narrow and steep, indicating reduced mixing potential. The curves for achromatic gray are flat, indicating no mixing potential.

A spectral reflectance curve is useful for the artist for two main reasons: First, to see the quality of the color reflected by a pigment. Second, to gauge the color-mixing potential when two or more pigments are mixed together. Pigments only have the potential to produce colors if there are reflected wavelengths common to both.

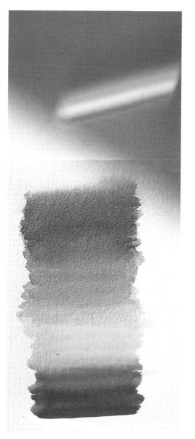

Left: The upper portion of the photograph shows the light-colors that comprise white light separated by a prism. The lower colors in sunlight are pigment-colors whose dominant wavelengths approximate the colors above: Thalo purple, French ultramarine, peacock blue, Winsor green, permanent green no. 1, aureolin yellow cobalt, cadmium orange, Winsor red, and a touch of alizarin crimson.

Right: Reflectance curves for white, Payne's gray, indigo, and permanent rose.

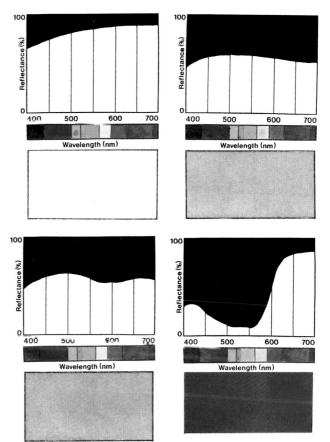

COLORS WITHOUT COLOR

Darkness, as in a night scene, is best portrayed by using black paint. Indeed, dusk and night scenes are the ones in which color can be darkened by adding black without destroying the overall color quality, for this is exactly what is happens to color at those times. Only at night, period of no light, is our color-cone vision inactivated, so we distinguish objects with our rod vision in black and white. As testimony to their importance as colors, black and white are the only colors included in all languages, even the most primitive. Black and white have interesting qualities related to color. The juxtaposition of black makes a color appear its lightest and white its darkest.

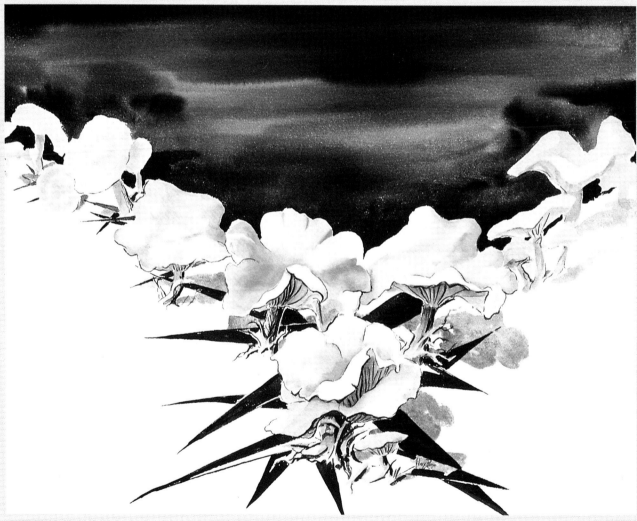

MUSHROOM I, 22 × 30" (55.9 × 76.2 cm).

LESSON 1 *Edge Contrasts*

One particular optical contrast was described by M.E. Chevreul as stripes resembling "channeled grooves." We have earlier called this a "fluted" effect. It is named Mach bands, after physicist Ernst Mach, who investigated the phenomenon in the 1860s.

Although *each* stripe registers uniform reflectance, the overall perceived effect is not uniform at all but of increased brightness and darkness at each edge. Mach proposed that simultaneous contrast was the reason for the phenomenon and, as we have noted, subsequent research has substantiated this.

My "cliffs" painting shows the fluted appearance which gives the illusion of mist between receding layers of cliffs—indeed an "optical" effect within the eye rather than an objective phenomenon.

If you want to do this painting yourself, wet the paper; wetting both sides will make it lie flat (though it will take longer to dry). Next, lay the wet paper on a rag laid flat over your board to avoid backruns around the edges. Drop in the premixed, very light gray pigment over the whole paper. Now dry your painting. Subsequent washes can be done with the paper dry.

Mary Jane Carpenter, **MORNING AT NESKOWIN BEACH,** 15 × 22" (38.1 × 55.9 cm).

A realistic scene displaying the Mach band phenomenon.

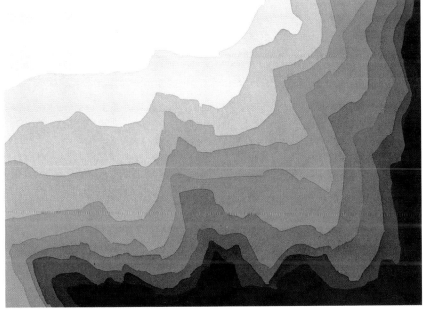

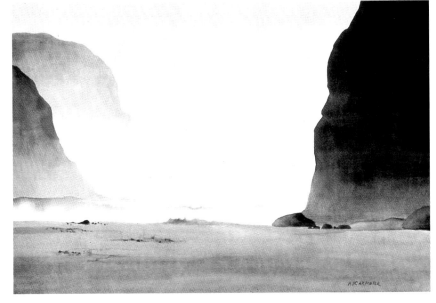

The washes here are uniform, yet as a darker layer meets the light of the previous wash, that immediate area appears lighter—as if there is a mist—and the cliff edge appears darker. This exemplifies the optical effect known as simultaneous value contrast, brought about by lateral inhibition and disinhibition within the eye.

Here is a guide to four pigments I use, giving their properties, derived from my handling tests, along with the Color Index numbers and components, as obtained from the paints' manufacturers.

Indigo made by Grumbacher consists of Vat Blue 1 73000. Other indigos on the market are mixtures, often of alizarin crimson, lamp black, and Winsor blue. If you don't have indigo, you can mix a similar hue yourself from these paints or, as I do, from aureolin manufactured by Holbein (monoazo and hydrous iron oxide), permanent rose quinacridone with alizarin crimson and Prussian blue for darker shades.

Named after the Oriental indigo plant (Indigofera tinctoria), this deep blue fugitive dye, identified by Newton in the spectrum as being "like ultramarine," was first synthesized in 1800. The color varies considerably. It is the blue dye used for denim jeans, but the pigment indigo is much blacker and less blue. The spectral reflectance curve shows that the color is similar to black with a slight curve at the blue wavelength. The handling test shows the pigment indigo will not lift when rewetted and wiped.

Payne's gray, a mixed paint, consisting of alizarin crimson, lamp black, Prussian blue, and ultramarine, is a popular gray. You can mix the hue from sepia and Prussian blue. Sepia, it should be noted, originally made from the ink sacs of cuttlefish, is now composed of burnt sienna and lamp black to duplicate the original fugitive hue.

Lamp black (PBk6, 77266) was once made from the soot of oil lamps, hence the name. A synthetic organic pigment obtained by incomplete combustion of vegetable or mineral oil, it is one of the oldest pigments, said to have been used as early as the third millennium B.C. The tradition of Far Eastern drawing inks evolved from the production of this pigment, as did Chinese drawing sticks. The pigment is manageable when applied wet-on-wet. However, if you have too much water on your paper the "soot" will float on the surface, causing a halo effect. It will not lift when rewetted and wiped.

Ivory black (PBk9, 77267) was once obtained by "firing" pure ivory chips in tightly sealed iron pots. The name has survived, but because of concern for elephants, ivory has been replaced by animal bones. References to the pigment "elephantinium" can be traced back to 4th-century B.C. Roman literature. Calcium phosphate residue from the bone causes a brownish cast. The pigment works well when applied wet-on-wet. It will not lift when rewetted and wiped.

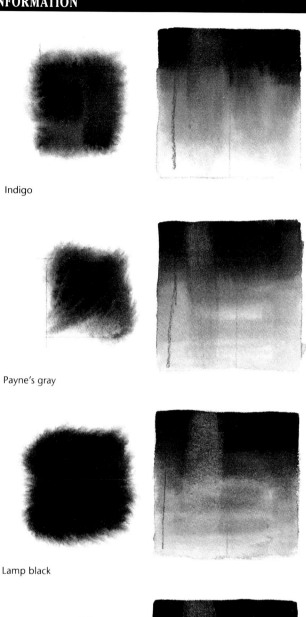

Indigo

Payne's gray

Lamp black

Ivory black

VALUE SCALES

I recommend that you take this opportunity to make a value scale to keep for subsequent lessons. The scale I show here is done with indigo, but you may want to mix your own hue.

Before doing a value scale, review your painting set-up. A useful set-up is shown in the self-explanatory illustration.

To paint the very light value of the scale, use wet-on-wet applications of gray watercolor. Subsequent stages were applied wet-on-dry.

Imitating the model shown here, create your value reference scale with successive washes, leaving the top band white—this is value 0. Lay in uniform gray-washed bands over rest of the scale, making the second band your value 1, the third value 2, and so on to the darkest band with the most wash layers. To give you practice in gauging the lightness or darkness of a color, it is a useful exercise to make a triple value scale in color, as shown.

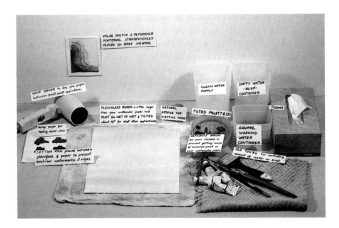

This painting set-up is for right-handed painters. Left-handers should reverse the set-up.

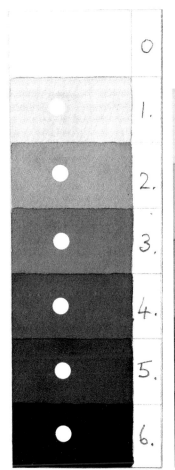

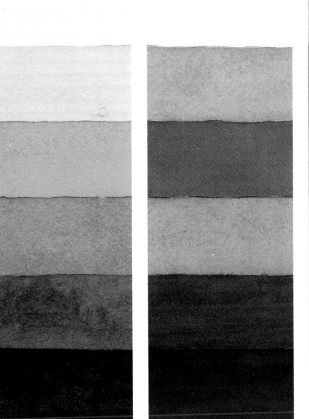

When your value scale is flat and dry, make sure the values and numbers are written in at the side. Then punch holes in the middle as shown. You will find it useful to lay the scale over colors to help you match similar values in colors.

These colored bands seem to indicate that the Mach band effect is caused by value rather than color. The far-left scale shows that the phenomenon is evident when a single color of progressively darker value is used for the stripes. The middle scale is one in which the values of the left-hand band are matched, while different colors are used. With the edges identifiable because of the color, the fluted effect disappears to a large extent. On the right, different colors all of the same value are used, and no fluted effect is evident.

LESSON 2 — *Craik–O'Brien Contour*

OPTICAL COLOR

Related to Mach band edge contrast is another optical effect known as the Craik–O'Brien contour, after its original observers. The phenomenon shows how the eye gauges the relative lightness of an area by the type of contour bordering it. Our featured color is gray. You can use Payne's gray or mix it from alizarin crimson, lamp black, Prussian blue, and ultramarine, or from sepia and Prussian blue. The eye seems to determine the appearance of an area by the nature of the contour surrounding it. For instance, in the double square illustration, the area bounded by the hard edge appears lighter than an identical area bound by a soft edge. When you cover the hard- and soft-edged dividing line with string, the two areas appear the same. Thus you can make two identical areas appear different from one another by separating them with a particular type of contour, hard-edged on one side and soft-edged on the other.

The Craik–O'Brien contour is particularly useful in high-keyed, light paintings such as the snowy scene opposite, for it extends the limited value range available to artists working on relatively dull white paper—especially when compared to the brightness of light-colors. The contour is also useful when portraying subjects with a wide disparity of value range, such as with an indoor scene looking outdoors; this is illustrated in the painting *Jill's Window*, at the end of this chapter.

Here, not just the immediate area—as with Mach bands—but total, identical areas are optically altered.

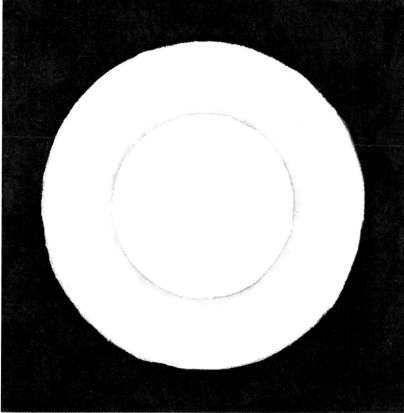

Referred to in this case as "Cornsweet's circular illusion," here is another graphic example of the Craik–O'Brien effect.

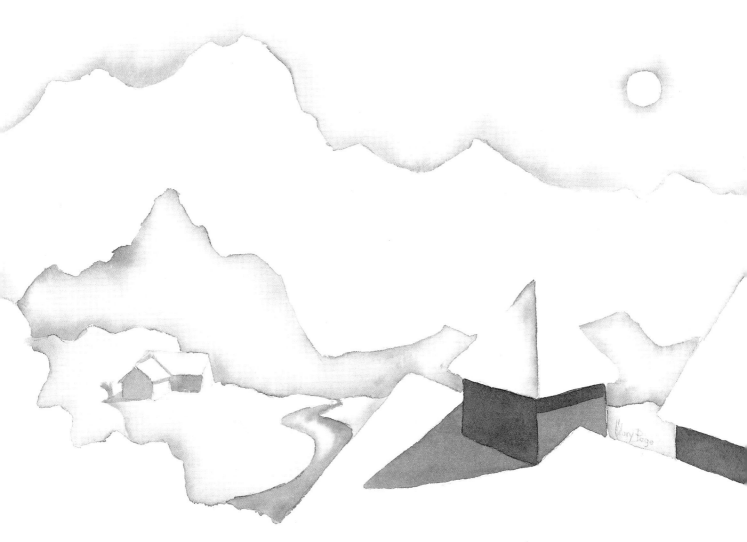

To employ a Craik-O'Brien contour along the distant mountain edge, I used a 1" flat brush to lay in about an inch of clean water. Then with a #6 round sable brush, I painted a narrow band at the edge to make one side of the band hard-edged. I blended the other side of the band into the water to make a soft edge, so that the whole sky appears slightly deeper in value than the mountain. Apart from the side walls of the turret and its shadow, every other area is bounded by a Craik-O'Brien contour to extend the value range and make unpainted white areas look gray

LESSON 3 *Portraying White Subjects*

DEMONSTRATION
FOREMAN'S HOME

COLOR LESSON: Using ultramarine deep and burnt sienna

CONCEPT: An old building

SEEING: White forms and shadows

DRAWING: Line drawing

COLORS: Ultramarine deep (Holbein), burnt sienna, raw sienna, aureolin, permanent rose, ivory black

PAPER: 8¹/₂ × 11" 140-lb. Arches rough

BRUSHES: 1" flat, #8, #3 round

ALSO: 3B pencil, liquid frisket, spray bottle, natural sponge; additional board with paper towels or flat cotton cloth on it, and a blade

PALETTES

Palette 1: Form and cast shadows: ultramarine deep (Holbein) (M), permanent rose quinacridone (M), aureolin yellow cobalt (M), raw sienna (t), burnt sienna (t) with ivory black (t) for door area. *Palette 2:* Roof: aureolin (t), ultramarine deep (t), burnt sienna (S). *Palette 3:* Sky: ultramarine deep (M), raw sienna (S), burnt sienna (t).

The stages of the "white" building, photographed when painting on location, show an unusual approach to a subject which you may wish to try. As you can see, the building's paint was so old that my subject actually was not white at all. You'll see how I use an optical illusion to depict it as such.

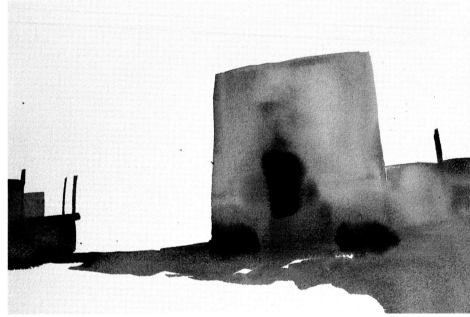

STAGE 1

To achieve a bold approach, and also for the speed which is necessary on location, I did not predraw the subject. I painted the building's form and cast shadow on dry paper to make one powerful shape as shown. The granular quality of ultramarine deep would be lost had I reworked the paint once laid on the paper. For strong, unified paintings such as this one you have to learn to combine values to make one shape, even though in real life the objects—the building, fence, boat, and shadow—are separate, as here.

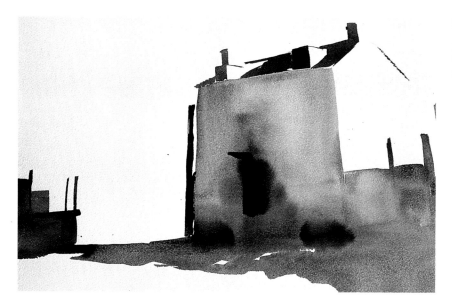

STAGE 2
I defined the "white" side of the building by painting the front part of the roof and the edge tiles on the far side.

STAGE 3
I wanted to portray an old white building losing its whiteness. I defined the total building shape by adding the sky. For the soft clouds I wet the paper first and then laid in a wash of premixed greenish blue-gray. I added a few details, mostly using my 1" flat brush so as not to diminish the powerful statement.

I left the foreground white. Juxtaposed with the dark cast shadow, it makes the white area appear even whiter. The eye then compares this white with the white in the building, this time juxtaposed with middle gray colors. Naturally, the eye assumes that by comparison the building is not particularly white.

59

LESSON 4 *"White" Shadows*

If not white, what color are "white" shadows? That is what we will investigate in this lesson. First, let's review some information about shadows—namely, form and cast shadows. Form shadows are the shade side of the form, or object. Cast shadows are shadows that one object causes to fall on the surface of another.

OBJECTIVE COLOR

The photograph on the facing page shows a white model of a building's overhang, such as on a storefront, resting on a beige ground. The model was so lit that the overhang cast a shadow onto the white area. This shadow took on a yellowish hue reflected from the sandy-colored ground—just as a building's shadow would take on blue-gray colors reflected from the sidewalk—until the addition of the brightly colored objects.

Far from being a uniform gray, shadows on a white building contain a multitude of reflected colors. Blue light reflected from the sky is a major influence in the shadow color outdoors. Our demonstration illustrates shadow colors influenced by many surrounding, brightly lit colors.

Thus, again, beware the boring Payne's gray shadow trap. Mix your white shadows from three particular primary colors—namely, aureolin yellow cobalt, permanent rose quinacridone, and cobalt blue. As a light-valued blue that can never be applied dark, cobalt blue is suitable for white shadows. When combined, the three pigments will separate out a little and make an interesting chromatic gray.

Margo Vance, **ST. FRANCIS DE PAULO**, 22 × 28" (55.9 × 71.1 cm).

The church has violet shadows, an effect the artist achieves by glazing single pigments one over another: Winsor red, yellow, and blue.

In this model of sunlit colored objects under an overhang, note how the cast shadows are strongly influenced by colors reflected from the objects.

EDELMANS, 22 × 33" (55.9 × 83.8 cm).

You must experience shadows' appearance on location. You will only understand their subtle colors by sitting outside and witnessing the ever changing shadow as you paint and observe. I had just launched into painting the critical long shadow cast by the overhang, when two locals parked their vans in front of my subject. Luckily I was able to return to the same spot the next day and managed to portray a vibrant cast shadow.

A SPECIAL PROBLEM

Portraying scenes in which there is a significant light differential—as in my interior, *Jill's Window*, which juxtaposes interior shade and exterior sunlight—presents a challenge for the artist. As with photography, the range of values one is able to portray, from the lightest to the darkest, is much reduced. Also, the luminosity of light (and certainly of sunlight) simply cannot be matched. Here are some mechanisms and ideas the artist can utilize to portray such a scene convincingly:

1. Make the interior part lighter and the outside colors de-saturated. This will make the viewer concentrate on the interior scene.

2. Make the interior section dark, so the well-lit section, portrayed with middle-valued colors, is framed by the dark. This would apply to a view seen through an open door. The viewer will disregard the dark section and concentrate on the lighter outside scene.

3. Make both the interior and exterior of similar value and ignore the light differential. (Andrew Wyeth does this in his works, using the subject and design to guide our eyes back and forth from interior to exterior.)

4. Under dimmer light, colors become increasingly neutral. It is possible to reverse this to make colors dark in value but still relatively saturated. This should draw attention to an area that the eye would otherwise pass over.

5. Utilize simultaneous value contrast to fool the eye. By juxtaposing a light area with a dark one, the light will appear lighter by comparison.

6. Utilize the Craik–O'Brien contour. You will recall from the snowy scene earlier that it is possible to make an area appear less light by merely bordering it with a soft- and hard-edged band.

It is a good idea to go to museums and galleries and also to look at reproductions of paintings in books to see how other artists have solved the problem of portraying a scene with great light differential.

H.C. Dodd, **SPANISH ARCH**, 30 × 22" (76.2 × 55.9 cm).

In realistic representations, if you are portraying an interior scene with no window the white or light areas can be the white paper. Once you include a window and bright light outside, the contrast will mean that interior walls (unless direct sunlight hits them) will be darker than the exterior scene and cannot utilize the white of the paper.

JILL'S WINDOW, 22 × 28" (55.9 × 71.1 cm).

Here is how I tackled the problem of portraying the disparity of light quality between outside and inside, while still maintaining the "white" quality of interior paintwork: I was helped in making the outside light appear lighter because there was a black line around the window panes, made by the outside paint. This dark line served to make the outside colors appear lighter. The values of colors on the inside wall and the curtains where not back-lit were darker than the other colors. I painted the white wall a chromatic gray to indicate reflected color from both the oranges in a bowl and the curtain. Portraying "white"

in this way presents problems because it is easy to make the gray dull and lifeless. Together with the curtains, this darker area serves to make a frame around the lighter window.

Portraying the middle values such as the objects on the windowsill required more thought. I made the sunlit leaves appear particularly light by encircling them with a Craik–O'Brien contour, by having a hard edge abut the leaves, to make them appear lighter, and by graduating the other edge to make it soft. Thus by comparison the outside colors appear slightly darker, without actually being painted so.

YELLOW

A brilliant yellow, the color we associate with sunshine, gold, and daffodils, suggests well-being, opulence, and resurgence. It is also associated with the mind. Of all colors, yellow reflects the greatest amount of light; indeed, when dull, yellow becomes mustard or mud and less recognizable as yellow. In bright-light–adapted vision, known as photopic vision, yellow is the color to which our eyes are most highly attuned. Reflectance curves show that lemon yellows and aureolin yellow cobalt reflect over the broadest portion of the spectrum and thus have the greatest mixing potential. Unsaturated yellows—yellow ochre, raw sienna, and raw umber have flatter curves, indicating reduced mixing potential.

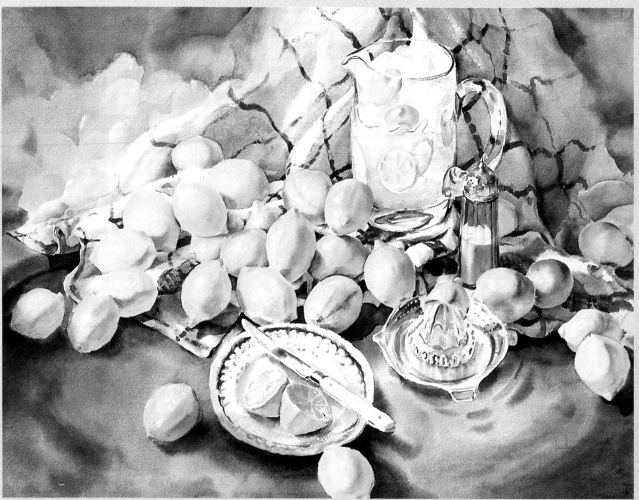

SUMMER COOL, 22 × 30" (55.9 × 76.2 cm).

Reflected Color and Value

Lemons, from which lemon yellow gets its name, are a green-yellow when freshly picked. They darken with age, ranging from the color of cadmium yellow pale to cadmium yellow and even to cadmium yellow deep. Their light yellow color makes lemons an ideal subject from which to study reflected color and value as it relates to color.

OBJECTIVE COLOR

Reflected color is objective—that is, unlike the optical effect of simultaneous and successive contrast, it is a phenomenon measurable by instruments outside the eye. It is useful to study the effects of reflected color on intrinsically light subjects such as lemons because the mixes of color are readily apparent. You can then apply the knowledge of reflected colors as you paint other colored subjects on colored grounds. The reflected color may not be so obvious, but you will know how to paint shadow areas accordingly. For instance, on a lemon, shadow color is enhanced and the yellow becomes quite saturated when set on a yellow ground. It is dulled and neutralized when placed on blue or purple, the complements of yellow. The shadow's yellow undergoes a hue shift when the lemon is on a color analogous to yellow: yellow on a rose ground makes the shadow orange; yellow on orange produces a bright orange yellow, and so on.

DEMONSTRATION
LEMONS

COLOR LESSON: Using cadmium yellows

CONCEPT: Lemon study

SEEING: Reflected light and color in shadows

DRAWING: Value sketch, drawing a circle in perspective

COLORS: Cadmium yellow pale, cadmium lemon, cadmium yellow, aureolin yellow cobalt, permanent rose quinacridone, permanent blue ultramarine, cadmium red deep, alizarin crimson hue

PAPER: 7 × 11" 140-lb. Arches rough

BRUSHES: #12, #8, #6, #3 round

ALSO: 12 × 16" plexiglas sheet

COMPOSITION

You'll need three lemons for this study, placed at different angles to give more information about your subject. The cut lemon shows a circle in perspective, a facet of drawing that recurs constantly. I placed my lemons by a window, but not in direct sunlight. I also used a fluorescent lamp to cast interesting soft-edged shadows. It will benefit you to work through this simple "value" exercise to sharpen your painting and visual skills and to thoroughly master value and color relationships. There is a lot of information in the simple line drawing for this painting, so study it carefully.

VALUE

Value involves the relative amount of light a subject reflects, color notwithstanding. Since value is a property of color, it is necessary to understand the concept of value to be able to portray color. For this early demonstration, we will look quite closely at making a representative value sketch. This is a useful practice for any subject you paint, because as you explore the relationship between the lights and darks you will facilitate the painting process. Refer to the terms you will need to understand before you can make a representative value sketch.

Shades of yellow vary in the shades of lemons on seven differently colored backgrounds.

My set-up calls for lemons on a white background.

Once you have a simple line drawing, examine the stages of a five-value (values 0–4) representative value sketch, shown in the illustrations.

PALETTES

Remember that this is a small painting, so the relative quantities of each paint are much less than for a large painting.

Palette 1: Lemon segments and shadows: aureolin yellow cobalt (M), permanent rose quinacridone (M), permanent blue ultramarine (M). *Palette 2:* Lemons: cadmium yellow pale (L), cadmium yellow lemon (S), cadmium yellow (S). *Palette 3:* Deeper shadows: cadmium red deep (S), permanent blue (S), cadmium yellow pale (S), cadmium yellow (S).

VALUES: SOME USEFUL TERMS

Representative Value Sketch: a drawing that accurately represents the values (lights and darks) without invention.

Creative Value Sketch: a drawing with a creative interpretation of the values seen.

Color Sketch: a drawing that records colors and value information as a reference for a painting.

Ground: a surface on which a three-dimensional object rests or against which it is seen.

Form: a three-dimensional object.

Form Shadow: a shadow appearing on the form itself on the side turned away from the light source.

Cast Shadow: a shadow cast by the form onto another surface. A cast shadow is commonly darker than a form shadow when the values of both surfaces are the same. Thus, when a white form throws a shadow on a white surface, the cast shadow will be darker than the form shadow.

Core Shadow: a core of darker shadow between the light and shadow areas on all curved surfaces. The core shadow is particularly apparent when the curved form is illuminated by strong direct light.

Local Color: the endemic color of an object without consideration of light or shaded areas of it. For instance, the local colors of a tomato and lemon are red and yellow, respectively.

1. The ellipses of the cut lemons have a heavy line to help you distinguish the shape of a circle drawn in perspective.
2. The cast shadows are indicated by broken lines with dots.
3. The heavier broken lines around one lemon and in an extended area around the cast shadow indicate painting instructions—where to prewet your paper prior to painting that particular lemon and shadow. The arrows show where the lemon and cast shadow can be joined to allow specific paint mingling and separation.

To avoid erasing and damaging the paper's delicate surface, draw your subject on sketch paper and then trace it onto the paper using a light table or window to backlight it.

Values 0 (white) and 1 (light areas):
Squint to identify the lightest area on the subject and then lightly shade every area except these lights, which on colored objects are often the highlights. The shading becomes Value 1 and encompasses most areas in direct light.

Value 2 (shadows; here, reflected light in form shadows):
Squint to identify the third-lightest areas, which in this set-up
are the combined form and cast shadows.

Value 3 (darker areas—specifically, core and cast shadows):
Squint, then shade the core shadow and cast shadows and any
other areas of similar value. Note that even though the lemon
is darker in value than the white paper, the cast shadow is still
darker than the form shadow.

Value 4 (dark accents within cast shadow and stem):
Because the lemon form is curved, there is little
light as the surface curves downward. Thus the cast
shadow appears particularly dark adjacent to the
lemon. Add other dark details.

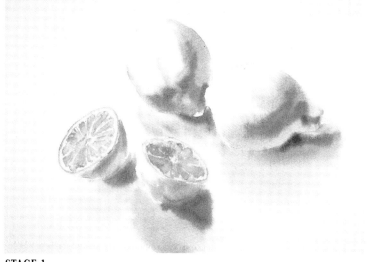

STAGE 1

Start with transparent aureolin yellow cobalt dulled a little with the addition
of permanent rose and permanent blue. Drybrush the lemon segments to
give the impression of reflected light on a shiny surface. Use a small round
brush, such as a #6, and stroke the paper to lay in the paint. Leave some
white paper between segments and around the outer edge. The color is
deeper where the segments are in shadow.

With your board flat, and using a #12 round brush, separately prewet
one lemon and its cast shadow, adding an extra inch of water around the
cast shadow; this will ensure that it is soft-edged. Leave a very narrow
band of dry paper between the lemon and shadow, as indicated by heavy
broken lines in the line drawing. Using a #8 pointed round brush,
separately drop in the gray shadow colors within the lemon and cast-
shadow areas. Indicate darker values by adding paint with more pigment
and less water. The gray can be slightly yellower in the shadow where the
lemon and cast shadow reflect yellow off one another. Join the lemon and
cast shadow where indicated on the line drawing by arrows. Dry each
lemon before progressing to the next. If your underpainting is too light,
dry your paper first and then repeat the process and add more gray.

STAGE 2

Lemons vary in color, and cadmium yellows provide the range. Cadmium yellow pale was the color of the main body of most of my lemons, though they were cadmium yellow lemon near the highlights, and cadmium yellow or cadmium yellow deep in shadow. Check how your lemons look before painting. Again, work each lemon separately by prewetting one and then dropping in the yellows. Take care to leave the highlight area white. Dry before progressing to the next lemon.

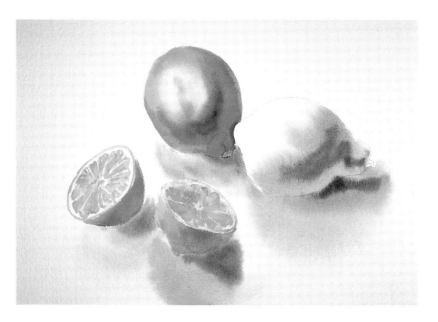

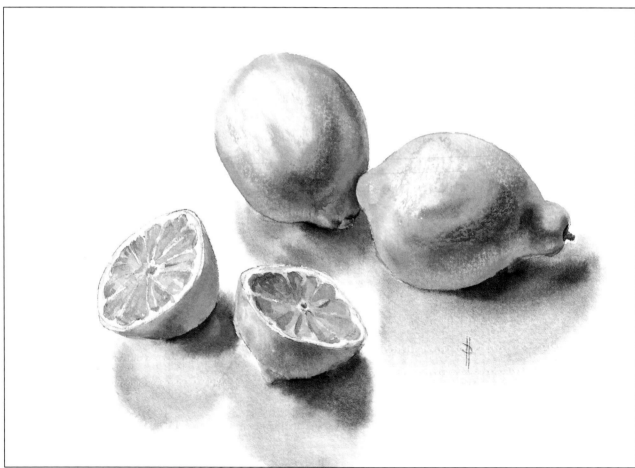

STAGE 3

As with all curved forms, the shadow area will be particularly dark in the immediate area where the lemon curves downwards to touch the ground on which it is resting. This area is often the shape of a new moon with the outer edges softened with water.

To portray a lemon skin's texture, drybrush some yellow into the highlight, but take care that the color is the same hue, not darker than the surrounding yellow. A way of portraying reflected light in the form shadow is to spread water over the

area and then wipe off the paint with a tissue. Cadmium yellows do not lift very much, just enough to create texture, especially if you are using rough watercolor paper.

Details such as the green for the stems, for which you add a little blue to your segment color, need to be dark in value if they are in shadow. There are always a few adjustments you will want to make to clarify the image. In this study, I worked on the lemon segments some more and squinted to double-check the values of form and cast shadows.

Here is a guide to eleven yellows I use, giving their properties, derived from my handling tests, along with the Color Index numbers and components, as obtained from the paints' manufacturers.

Winsor yellow, Hansa yellow light, and lemon yellow (PY1, 11680) are lemon and light varieties of arylamide yellows. They are insoluble organic dyes that precipitate directly as a pigment, unlike the lake pigments, which have to be precipitated onto a transparent inert pigment to make them insoluble. The chemical composition of these yellows varies slightly, as does the lightfastness, according to the quality of the pigment used. Winsor yellow appears a very greenish lemon yellow. My lightfast test shows the pigment to be stable; there is no sign of fading. The physical handling test shows that the paint spreads when applied wet-on-wet and will not lift when rewetted and wiped off.

Cadmium yellow lemon, as manufactured by Holbein, has an unusual luminous quality. See cadmium yellows.

Aureolin yellow cobalt (PY40, 77357) is the synthetic inorganic pigment cobalt yellow, named aureolin ("crown of gold"). Discovered in 1848, in Breslau, Germany, by N.W. Fischer, it was first sold as a paint in England and the United States in 1889 by Winsor & Newton. It is particularly useful because it is transparent and tincturally "balanced," so it leans to neither the green nor orange side of the color wheel. The reflectance curve shows that it reflects over a broad portion of the spectrum, indicating extensive mixing potential. Indeed, around 1925, the Leipzig painter Arthur Mühlberg used aureolin as one of three basic colors, with alizarin crimson and Prussian blue, to mix all necessary shades, including black. Aureolin is easy to use because it does not spread uncontrollably when applied wet-on-wet. It lifts readily when rewetted and wiped off, making it ideal for direct painting though not so suitable for glazing. It is very lightfast, but it is sensitive to heat and decomposes with heat, acids, and alkalis. This color is not to be mistaken for pigments on the market named aureolin that do not contain cobalt.

Aureolin (Holbein) (PY3, 11710; PY42, 77492), not to be confused with aureolin yellow cobalt, comprises two pigments: monoazo yellow and hydrous iron oxide, a very lightfast synthetic inorganic pigment used in yellow ochre. The paint was developed to match aureolin yellow cobalt in hue, though it is slightly less saturated. The handling test shows that the paint is manageable when applied wet-on-wet. It stains the paper and when rewetted and wiped off it will not lift very much, apart from the thickly applied portions that have not penetrated the surface of the paper.

Winsor yellow

Cadmium yellow lemon (Holbein)

Aureolin yellow cobalt (Winsor & Newton)

Aureolin (Holbein)

Hansa yellow (PY97, 11767), a pigment with very fine tinting power, can be used in place of new gamboge in many instances.

New gamboge (PY1, 11680; PR3, 12120) is a Winsor & Newton orange-yellow composed of arylamide yellow and toluidine red of the azo group, plus a nickel complex. The pigment is named after the rich golden hue of fugitive genuine gamboge, a gum resin of the Garcinia group of trees indigenous chiefly to India and Thailand. The "genuine" ingredient has been discarded in favor of the more lightfast synthetic copy. The hue and specific pigment content varies considerably with each manufacturer. I sometimes use gamboge hue manufactured by Rowney because it has a pleasing orange-yellow. The physical handling test shows that the pigment halos when applied wet-on-wet and also "ozzles"—that is, forms inward-moving watermarks.

Cadmium yellow and cadmium yellow pale (PY37, 77199) are made from the mineral greenockite, or cadmium sulphide. The color of cadmium sulphide ranges in hue from lemon to a deep orange, depending on the presence of impurities. Although it appears very opaque when first applied, it becomes more transparent when dry. However, when mixed with colors other than their immediate neighbors on the color wheel, the cadmium yellows produce rather turbid color, despite the potential indicated on the reflectance curves. The test samples show that they do not lift readily when rewetted and wiped off, so be sure you place them correctly in your painting the first time around. When applied wet-on-wet the deeper shades spread out somewhat. The pigments have a radiant quality, making them seem to exude more light than the illumination warrants. If you hold your cadmium test samples sideways you will be able to see how the color emits more light than the paper.

Hansa yellow (Daniel Smith)

New gamboge (Winsor & Newton)

Cadmium yellow (Winsor & Newton)

Cadmium yellow pale (Winsor & Newton)

Yellow ochre (Winsor & Newton)

Raw sienna (Winsor & Newton)

Raw umber (Winsor & Newton)

Yellow ochre (PY43, 77492), a native earth containing hydrated ferric oxide, chiefly goethite, has been universally used as a pigment, even in prehistoric cave paintings. It is found worldwide and is retrieved predominantly by open-cast mining. Highest grades of yellow ochre occur in southern France. Recent manufacture of hydrous iron oxide chemically in a great many shades has reduced paint manufacturers' reliance on a specific source for a specific hue. It is lighter and less red than raw umber, but its handling characteristics are similar (see below).

Raw sienna (PY43, 77492), like yellow ochre, is hydrated ferric oxide (goethite) with alumina and silica. Raw sienna contains at least 50 percent iron oxide, accounting for its warm, neutral hue (yellow ochre contains about 20 percent, making it less warm). It is low in aluminum and high in silica, accounting for its opaque consistency. Raw sienna is slightly darker than yellow ochre.

Raw sienna was originally found in Tuscany, Italy, near Siena (with one "n") and also in Corsica and Sardinia. A few manufacturers now synthesize hydrated iron oxide for convenience; this produces a consistent and brighter hue. As you saw from the mixed-color wheel, you can mix and match the hue of these earth colors. However, you cannot match the sedimentary "earth" consistency so appropriate for landscapes. Both yellow ochre and raw sienna wash onto the paper quite smoothly, taking into account the granular quality of the pigments. When applied wet-on-wet, the very fine grains of pigment separate out slightly. When rewetted, yellow ochre wipes off more readily than raw sienna.

Raw umber (PBr7, 77491), like burnt umber, is similar to the ochres and siennas, but it contains manganese dioxide. The umbers have been available from earliest times but did not come into general use in Europe until the close of the 15th century. The paint test shows that raw umber is granular and does not apply particularly evenly on the paper in a heavy wash. It lifts readily when rewetted and wiped off and does not spread wildly when applied wet-on-wet.

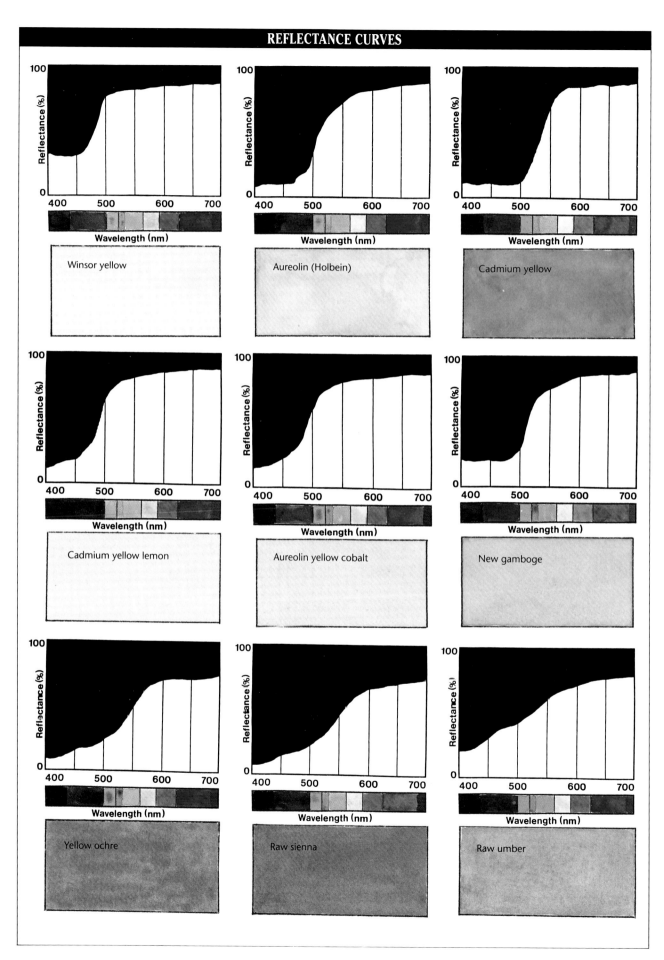

Winsor yellow

Aureolin (Holbein)

Cadmium yellow

Cadmium yellow lemon

Aureolin yellow cobalt

New gamboge

Yellow ochre

Raw sienna

Raw umber

LESSON 2 *Colored Shadows*

Portraying colors in shade is often a stumbling block for painters. Here, after seeing the reference photographs showing the actual color of shadows, you'll learn a basic method for mixing any colored shadow. Variously colored buildings in *Yellow House at Matagorda* provide a realistic scene for the study.

Our featured pigment is aureolin yellow cobalt and is not to be mistaken for pigments on the market named aureolin but not containing cobalt.

OBJECTIVE COLOR

The series of photographs illustrates how to quantify the amount of gray in shadow color.

Many of these color effects are duplicated in *Yellow House at Matagorda*, which shows how colored shadows are constituted.

There is an easy formula for mixing colors in shadow, duplicating the process indicated in the cylinder series: add *not* a premixed gray but a gray *mixed* from our three primary colors, permanent rose, aureolin, and cobalt blue or permanent blue. Make the gray lean in hue towards the color to be made in shadow. Then add the appropriate-colored gray to the color in shadow. Remember, cast shadows will be darker than form shadows when the local color of each is the same value.

DEMONSTRATION
YELLOW HOUSE AT MATAGORDA

COLOR LESSON: Colors of shadows

CONCEPT: Painterly interpretation of a country town

SEEING: Light and shadows on white and colored surfaces

DRAWING: Value sketch; direct painting

COLORS: Aureolin yellow cobalt, permanent rose quinacridone, cobalt blue, viridian, permanent blue ultramarine, alizarin crimson

PAPER: 15 × 22" 140-lb. Arches cold-pressed or rough

BRUSHES: 2", 1",1/2", 1/4" flat, #8, #6, and #1 round, #3 rigger

ALSO: Masking fluid

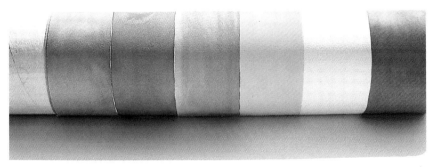

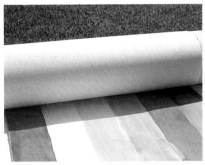

Note the white band of the cylinder where it rests on a white ground: the shadowed area appears quite gray when compared to the sunlit white. Closer inspection shows that there are various shades of gray, including a darker band of core shadow in the form shadow, and an even darker cast shadow. Now look at the colored bands. Here you see the same progression from light to darker color. You know from your previous observation that the addition of varying amounts of gray causes the darkening. You can also see how colors in the form shadow have a small influence on the cast shadow color.

Note how much the ground colors reflect back into the form shadow.

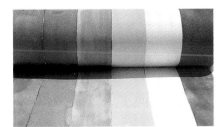

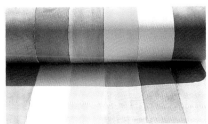

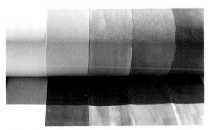

The same colors appear more saturated because of the addition of reflected color from the ground, as identified in the previous photograph.

Now the colors in shadow, receiving reflected colored light from an analogous color, undergo a hue shift and change color.

The colors in shadow become neutral as they receive reflected colored light from a complementary color (such as between yellows and purples/blues).

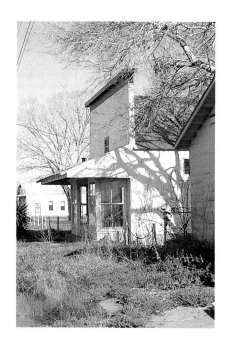

COMPOSITION

The reference photograph shows my scene. I will show you how I achieved my color effects so you can adapt the information for your own colored-shadow painting.

PALETTES

Mixing the colors is the most important part of this demonstration, so you will need to follow this section carefully.

Palette 1: Yellow building in sunlight and shade: aureolin yellow cobalt (L), with a warm gray for shadowed areas made from aureolin (S), permanent rose quinacridone (S), and cobalt blue (S). *Palette 2:* Sunlit and shadowed red roof: permanent rose (M), aureolin (S), cobalt blue (t), with a warm gray made from cobalt blue (S), permanent rose (S), and aureolin (S) for the same color seen in shadow. *Palette 3:* Sunlit and shadowed blue area: cobalt blue (L), with a blue-gray made from permanent blue (S), aureolin (S), and permanent rose (S). Add more water for sky blue and gray. *Palette 4:* Sunlit and shadowed green building: viridian (L) with a green-gray made from aureolin (S), permanent rose (S), cobalt blue (S). *Palette 5:* "White" shadows: aureolin (S), permanent rose (S), cobalt blue (S) with viridian (t). *Palette 6:* Various browns and greens: aureolin, permanent blue, viridian. Also permanent rose, alizarin crimson.

STAGE 1

The wide expanse of grass and weeds in the foreground led me to make a horizontal value sketch and to add a few more buildings so that I could show the green building in sunlight as well as shade.

To attain a loose, painterly effect, I did not predraw the scene but painted direct shapes, as if on location. Painting in this way is enjoyable but demands concentration.

I painted the massive shapes of the yellow building from which to gauge placement of other buildings. I next painted the green building in the foreground in a neutral green hue. Before painting the red roof, I masked off branches using masking fluid and a fine #1 brush. I prewet the sky before dropping in slightly neutralized cobalt blue and drybrushed the brown foreground undergrowth.

STAGE 2

The difficulty in painting the tree shadow is to keep the paint flowing, for as the local color changes, ground shadows are continuous. My shadow colors were premixed as previously described. Where white areas abut the colored, I switched to the yellow shadow color and thence to the red and blue. I prewet the cast shadow area under the overhang of the roof so that the two shadows would flow into one another without a break. Because of reflected light, form shadows such as that on the front of the building are lighter than cast shadows such as those cast onto the building by the tree. It is possible to gauge the minute differences in value of all the shadows only by squinting at your subject.

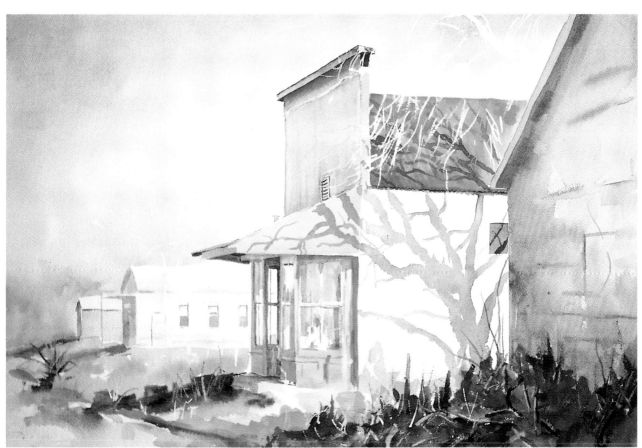

STAGE 3

Using varying shades, I laid in quite a thick layer of paint in green, yellows, and reds. Then, just as the shine was leaving the paper surface, I scraped out grass and weeds. Notice how the edge of the shadow is irregular as it moves across the uneven weeds. Before adding the boards on the green building I rewet the area and laid in a deep green to indicate a stronger shadow area.

The windows reflect what is in front of them. They appear quite dark in places, especially under the wooden sashes.

Adding a foreground reflection enables me to repeat the color to unify my composition, as we noted in the abstract square arrangements on page 41. The foreground reflection here unites the sky and foreground and also provides an opportunity to add more of the green building color. The road and foreground shape is designed to direct the eye to the interesting shadow and reflections on the yellow building, the center of interest. As intended, the overall effect is loose and painterly, resembling my on-location painting style.

LESSON 3 *Manipulating Color*

The color concepts expressed in this lesson are more complex than those in the other lessons but are essential to master if you are to use color well.

OPTICAL COLOR

There are several optical phenomena at work here to make the painting an example of effective color use and, in general, more dynamic than a realistic rendering.

First, I wanted to convey the brilliance of the yellow flowers. But how could I do this? If portrayed realistically as dots of yellow among green, the effect of the brilliant yellow color would be reduced *because the colors would mix partitively,* as in the Pointillism of paintings of Georges Seurat. Thus, to portray the effect of brilliance, the yellow flowers had to be a solid mass of color.

Second, I referred to my contrast color wheel to find a color that, when juxtaposed with a lemon green-yellow, would enhance that particular shade of yellow. That color is a purple-blue. This led me to use a very dark purple-blue for the tree trunks, to make the lemon yellow appear particularly bright and saturated.

Again referring to the contrast color wheel, I noted the unique interaction between purple and yellow-green. These colors are direct contrast complements.

THEORETICAL COLOR

A final factor contributing to powerful color is the distribution of values. There are two major interlocking shapes indicated by value: one light and the other dark. The light yellow shape takes up a major portion of the painting.

DEMONSTRATION
FIELD OF YELLOW

COLOR LESSON: Saturated color; also mixing greens

CONCEPT: To convey the impact of the brilliant field of flowers

SEEING: Reflected yellow light

DRAWING: Reducing the elements of the scene into a few interlocking shapes

COLORS: Permanent blue ultramarine, Winsor green, permanent rose quinacridone, aureolin yellow cobalt, Winsor yellow

PAPER: 11 × 15" 140-lb. Arches cold-pressed

BRUSHES: 1" flat, #6 round

ALSO: Masking fluid

For this exercise, you can create the same effects by following the demonstration as described, or you can find photographs of a similar scene. The flowers need not even be yellow—just a mass of a single color. By utilizing the simultaneous contrast information shown on your color modification sheet, and also by following the pairings set out on the contrast color wheel, you can determine effective color use based on the feeling you want to convey.

PALETTES

Palette 1: Deep blue sky and tree trunk: permanent blue ultramarine (M), permanent rose quinacridone (S), aureolin yellow cobalt (t). *Palette 2:* Greens: aureolin (L), Winsor green (S), permanent blue (t), permanent rose (t). *Palette 3:* Yellow flowers: Winsor yellow (L).

How to portray the brilliant yellow field of dandelions posed an interesting problem in color application.

Right: The flatness (indicating a neutral color) of the reflectance curves for dots of yellow and blue mixed partitively illustrates that partitive color mixing does indeed reduce color saturation. Far right: Compare the reflectance curve of the same two colors mixed subtractively. The green has the predictably steeper curve, indicating greater saturation.

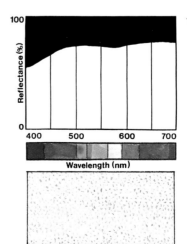

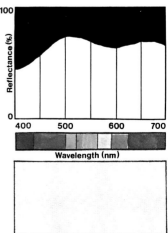

STAGE 1

I prewet the sky and dropped in premixed colors for the sky and distant trees. Making sure each stage was dry before proceeding to the next, I used a #6 round brush to drybrush the reflected yellow into the foreground trees. Apart from a slightly lighter foreground area, I laid in the field in solid yellow. Then I put in the purple tree trunks and branches and worked the gray into nearby grass as underpainting for shadows.

Before painting the yellow-green trees, I masked out the branches when the paper was totally dry. To create the appearance of leaves, while the original yellow-green wash on the tree was still wet, but just after the shine had left the paper, I dropped in deeper green in the shadow areas on either side of the branches. The original green underwash will not lose its shine uniformly, so I had to carefully drop in color at each spot at the optimum time.

Particularly desirable is the way Winsor green and aureolin separate when applied wet-on-almost-wet. Also attractive is how the permanent rose in the green mixture finds its way to the outside of the watermark.

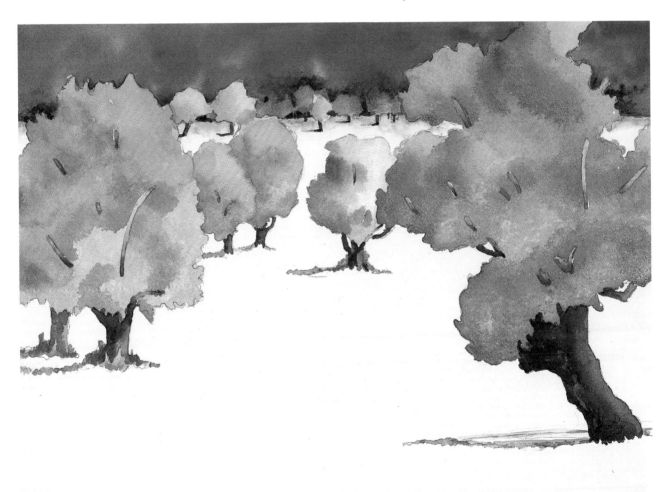

STAGE 2

I used an orange-yellow to make a transition between the distant edge of the field and trees. It should be noted that even if different colored, when the values are similar and the boundary is soft, an edge will not obtrude. I next negatively painted the distant trees by painting a darker green around some of them. Then I added the tree trunks. I added each tree's cast shadow on the yellow flowers. The color will reflect some green from the tree and some blue from the sky. Finally, I adjusted the tree trunk values, making it darker where the green leaves appear to protrude in front of it.

77

ORANGE

Orange, epitomized by the glow of the setting sun, flames, fall foliage, and its namesake among citrus fruits, suggests a color with a strong identity. Yet as a secondary mixed color its attributes are more associated with its neighbors yellow and red, too: vital, cheerful, and thoughtful like yellow; hot like red; and solid like the brown earth. Often its hue is distinguished only as "warm"—again as an appendage to yellow, red, and brown. Even its name came late: not until the fruit arrived in Europe from China in the 10th and 11th centuries did "orange" enter the lexicon. Orange's complement is cyan blue. The unsaturated orange colors are the browns.

FROM ESTES, 15 × 22" (38.1 × 55.9 cm). Collection of Jennifer and Gary Donnan.

LESSON 1 *Natural Earth Colors*

PIGMENT COLOR

It is appropriate to use natural earth colors to portray a naturalistic landscape. I used burnt sienna and burnt umber, which are unsaturated orange colors, to portray a gaunt winter landscape of earth tones, *Crundale*. Although it is not always possible to be in a part of the country where the earth colors are as red, with small adjustments the colors can be particularly evocative.

OBJECTIVE COLOR

If you squint at your landscape subject, you will notice that the land is quite dark compared to the sky. However, it is often necessary, as I have done in my painting, to make the land a little lighter and the sky darker for the most attractive color contrast effects.

OPTICAL COLOR

Within the sky itself, a white cloud can appear lighter when edged with a slightly deeper blue Craik–O'Brien contour. It is helpful to note (if you squint) that the lower gray part of a cloud and the blue sky behind it are of the same value and thus the edge between them disappears. Look for this the next time you are outdoors.

The contrast color wheel shows that orange and a green-blue are optical complements and so will enhance one another when juxtaposed. An appropriate blue for the sky, one that will optically enhance burnt sienna and burnt umber, is cerulean green-blue.

CRUNDALE, 15 × 22" (38.1 × 55.9 cm).

This landscape painting features two important unsaturated oranges, burnt sienna and burnt umber, and a cerulean sky. For the foreground, I darkened the earth tones with ultramarine blue.

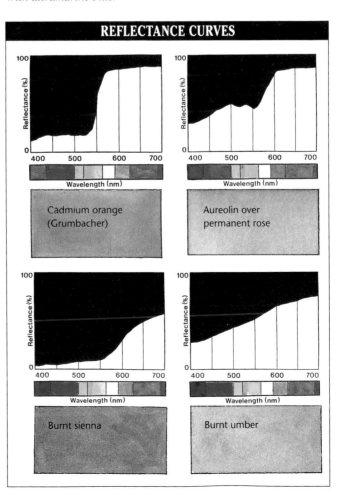

REFLECTANCE CURVES

Cadmium orange (Grumbacher)

Aureolin over permanent rose

Burnt sienna

Burnt umber

Here is a guide to seven oranges I use, giving their properties, derived from my handling tests, along with the Color Index numbers and components, as obtained from the paints' manufacturers.

Cadmium orange (PO20, 77202; PR108:1, 77202:1) as made by Grumbacher is concentrated cadmium sulpho-selenide or cadmium seleno-sulphide coprecipitated with barium sulphate; these are modifications of cadmium sulphide brought about by a change of acid proportion and by the addition of ammonium sulphide. As in all cadmium colors, this paint is highly toxic and very lightfast. Physically, it is a difficult color to use in watercolor. It spreads uncontrollably when applied wet-on-wet, and it will not lift when rewetted and wiped. Also, when you paint another color next to thickly applied orange, the orange can cause that color to creep into it, producing a fuzzy edge. This is a powerful and most unforgiving paint.

Cadmium orange (Winsor & Newton)

Cadmium orange (Grumbacher)

Cadmium red orange (Blockx)

Quinacridone gold (Daniel Smith)

Quinacridone burnt orange (Daniel Smith)

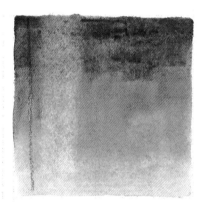

Burnt sienna

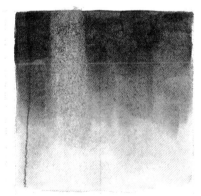

Burnt umber

Quinacridone gold and burnt orange (PO49, 73900/73920; PO48, 73900/73920) offer the painter more transparent and intensely colored browns than those of the earth pigments, and they can be used when you need a brown for something other than a landscape. They both spread a little when applied wet-on-wet, though this is hard to quantify since it is hard to use the same amount of water each time you do the test. The wetter the paper, the more the paint will spread and "ozzle." They will lift when rewetted and wiped. Although they have not stood the test of time for lightfastness, the quinacridones have a good reputation for lightfastness.

Burnt sienna (PBr7, 77491), made of calcined natural iron oxide, is a rich red-brown originally from Siena in Italy, its namesake. It gets its reddish hue when the natural iron oxide is calcined—that is, roasted in a furnace. Shades vary considerably by manufacturer. As a natural inorganic "earth" pigment, burnt sienna is extremely lightfast. Some fine particles creep when applied wet-on-wet, causing interesting color effects when mixed with nonmoving granular pigments such as ultramarine deep (Holbein). Burnt sienna does not lift when rewetted and wiped.

Burnt umber (PBr7, 77491), made of calcined natural iron oxide, is a deeper and less red pigment than burnt sienna, though it too is roasted in manufacture. It is closely related to the ochre pigments but has a high proportion of manganese dioxide, which imparts the brown appearance.

LESSON 2 *Mixing Oranges*

PIGMENT COLOR

Many of the premixed oranges on the market may not be particularly lightfast. Thus, instead of featuring a specific pigment for a transparent orange, you can mix the color from two synthetic organic pigments. In *Fall Trees' Flames*, I used gamboge (Rowney)—a red-yellow—and permanent rose quinacridone.

OBJECTIVE COLOR

The red, yellow, and orange leaf colors of autumn appear particularly saturated when back- or side-lit, giving them a translucent quality. Reflection of color onto leaves on the trees from those on the ground further enhances color saturation. In direct sunlight, leaf colors are somewhat bleached in appearance because the sunlight reflects off the leaves' shiny surface. Trees with translucent leaves do not conform to the usual "sphere" shadow formation, because the core shadow is obscured and the form shadow is rather flat. Adding to the difficulty in portraying fall trees is the great variation of

colors, for the leaves do not turn simultaneously. Often the inside leaves are green and the outside leaves are various shades of yellow, orange, and red. In sharp contrast to the brightly colored leaves, shadowed tree trunks and branches appear particularly dark in value, but in sunlight they match the values of the leaves and are barely visible (see upper right in photo).

OPTICAL COLOR

Although very brilliant and eye-catching, the analogous-color scheme of yellow, orange, and red can be cloying. A small amount of contrasting blue to complement the orange will enhance the warm colors and improve the visual effect (see below).

WORKING WET-ON-WET

To create *Fall Trees' Flames*, I aimed for a translucent effect. I mixed my bright colors from staining pigments and laid them in primarily with a wet-on-wet technique.

Before squeezing out the paints, I soaked my paper using a natural

sponge and laid it on my plexiglas board. I spread water over the front, back, and front again. The sodden paper then stuck to the board's slick surface. I left a film of water over the front side to soak the paper some more while I squeezed out and mixed the colors I would be using. When working wet-on-wet, it is very important to have all the colors you will need ready to go as soon as your paper is fully soaked.

I put a flat cotton rag over a board identical in size to the original one. I planned to transfer the wet painting to this board as soon as I finished laying in the paint to prevent backrun watermarks around the edges.

Note the various effects of sunlight on this tree.

Right: A grid of only analogous colors amounts to an overloaded color scheme. Far right: Introducing a complement such as blue begins to make the scheme more satisfying.

In doing this on-location color sketch, I did not find the trees to be a mass of color, so I emphasized the colors I wanted—autumn oranges, reds, and yellows— and de-emphasized the greens that were still plentiful. One often has to use a similarly imperfect setting for inspiration. For a moment the sun came out, causing long shadows cast by the trees across the ground. Then I had the germ of an idea for a composition and made a value sketch.

Working from light to dark, I laid in the colors of an underpainting: cobalt blue for the sky and underpainting shadows, and greens, bright reds and then yellows and oranges for the foliage on the trees and ground. Later, working on the dry surface, I defined the layers of foliage, from light orange-reds to dark ones. Each outer edge was hard, and the inside edges were softened with water. I constantly referred to my value sketch to ensure that I was indicating the unique shadow shape that I wanted. I firmed up some edges of foreground foliage, without overworking them. I think the simplicity and understatement give this painting its dynamism.

RED

Dominant red demands attention. It is the color of force, passion, and energy, and also of blood and war. After black and white, words for red are found in the greatest number of languages. It is a color of extremes: located at the top of the rainbow, red has the longest wavelength, and the lowest energy level. The reflectance curves show that cadmium reds, Winsor red, and Indian red reflect mainly in the orange and red wavelengths and partially in the yellow. Therefore its mixing potential is limited. The curve for Winsor red shows a lot of white in the graph, but this is because the painted sample color is light and desaturated. However, the character of the curve is the same as that of the cadmium reds. Indian red, which is more neutral, has a flatter curve.

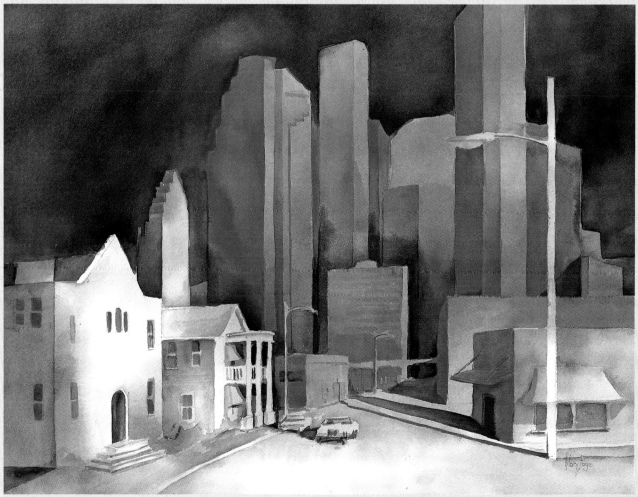

DOWNTOWN, 11 × 15" (28 × 55.9 cm).

LESSON 1 *Red's Impact*

That red is dynamic and powerful is illustrated by the two harbor photographs shown here. We are drawn to the first photograph because of the red boats. The second is the same scene with the same elements but with only a small patch of a red. The general impression is much less eye-catching.

If a composition were to consist wholly of red tomatoes, the addition of a single contrasting element, say a green tomato, would draw attention even more than the red, pointing to the fact that contrast is more powerful than the intrinsic power of a color.

Red has the attribute of appearing to advance in a composition when compared to other colors, especially dark blue, which appears to retreat. This has been illustrated by Lois Swirnoff in her book *Dimensional Color* (1992). She conducts an experiment whereby she photographs two illuminated blocks, a red and a blue one, in a black tunnel. The red block is placed farther back than the blue one, but is larger in size to counteract the diminishing effects of perspective. Thus, both blocks when viewed head-on ought to look exactly the same size. Yet the red one still seems to advance.

Comparison of these photos illustrates the dynamic, attention-catching impact of red. Judicious placement of bright colors in a composition is important. Even the small amount of red in the second photograph draws our eyes to the lower-right corner. If you put your finger over the distracting red, your eye will then be drawn to the more central yellow boat.

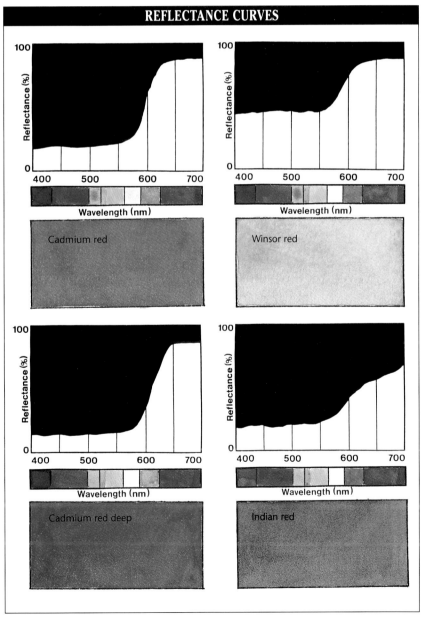

STAGE 3

I mixed a neutral red similar to Indian Red for the building. I painted boats and reflections in sections. The water, dark and wavy, distorts the reflected image. I extended the red area into the boathouse and poles to avoid cutting the painting into a red half and a blue half. Cadmium red dries much lighter than when first applied, so you may need to lay in a second wash after the first has dried to make a deep, saturated red.

STAGE 4

This stage requires detailing and re-evaluating. You can adjust edges by softening a hard edge with water and graduating the wash. The eye will be drawn to hard-edged high-contrast areas. You can darken an area by adding washes or lighten it by lifting, erasing, or scraping. Always squint when you adjust values, and examine your work in a mirror. Finally, check to make sure your center of interest is strong.

LESSON 2 *Glazing Pigments: Reflected Color*

The following demonstration of red, green, and yellow peppers provides the opportunity to use a glazing technique to induce a color quality so realistic that you'll feel you can pluck the peppers from the paper. We'll also analyze reds influenced by color reflected from a yellow and green pepper. The featured pigment is Winsor red, a synthetic organic pigment.

The red pepper influences the form shadow of the white pepper, tinting it with pink. The same pink on the yellow pepper makes the yellow form shadow appear more orange.

The pink makes the green pepper's form shadow appear more neutral. You can thus conclude that the form shadow of a red pepper receiving pink light from an adjacent red pepper will appear a more saturated red.

Note also that the peppers' shiny surface makes the general color appearance more saturated and the reflected light and color more pronounced.

OBJECTIVE COLOR

As we have seen previously, different-colored adjacent objects reflect colors onto each other. If you know what to anticipate regarding color, you know what to look for when you are observing a subject. Examine what color phenomena occur in the yellow, red, and green peppers shown here.

OPTICAL COLOR

The optical simultaneous and successive contrast effects are not particularly marked in this composition, for as you can see from your contrast color wheel, the particular red and green of these peppers are not additive complements; thus they will not enhance each other's color. The three colors are in fact quite related, because each reflects yellow wavelengths as well as its dominant color, making for a harmonious color scheme.

DEMONSTRATION
RED, YELLOW, AND
GREEN PEPPERS

COLOR LESSON: Underpainting shadows to achieve neutral shades

CONCEPT: Realistic rendering of brightly colored peppers

SEEING: How colored surfaces reflect colors onto each other

DRAWING: Making a value sketch as a guide for watercolor

COLORS: Gamboge, or Hansa yellow, Winsor blue, Winsor red

MATERIALS: 6B graphite stick, 3B pencil

BRUSHES: 1" flat, #8, #3 round sable

PAPER: 11 × 15" 140-lb. Arches cold-pressed

ALSO: Rags, paper towels, Art Gum eraser

This is another demonstration that enables you to work from your own three-dimensional edible subject. To achieve a translucent effect we will use the layering watercolor technique known as *glazing*. The paint of a wash must be completely dry before applying a subsequent wash. We will use so-called dye pigments, which stain the paper and are undisturbed by rewetting and overpainting.

COMPOSITION

On white paper, place your peppers close together so that the colors reflect off one another. Arrange them in an attractive configuration; turn the peppers slightly so that you can see the more interesting back or front part. Illuminate your subject with an indirect light source, not in direct sunlight. If you are working at night, illuminate the subject with a blue plant light or with fluorescent lighting. Beginners may want to paint just one or two peppers to start with.

Making a line drawing and value sketch prior to painting will help to familiarize you with your subject. Notice how the peppers consist of chunky curved sections. Form shadows on curved surfaces are also curved, as are the core shadow and areas of reflected light within the form shadow. Accurate assessment of values is the only way you will make the subject three-dimensional and real. When you paint, you can use your value scale (page 55) to check the accuracy of your values.

PALETTES

Palette 1: Yellow: new gamboge or Hansa yellow (L). *Palette 2:* Winsor blue (S). *Palette 3:* Winsor red (M).

STAGE 1

First, apply the yellow and blue of the underpainting. Glaze in a yellow in the areas shown, working one pepper at a time. Then use your 1" flat brush to prewet the total area within the broken lines and your #3 brush for intricate shadow areas. Wet all the pepper and the cast shadow area, leaving a hairline strip of dry paper between the pepper and the cast shadow. Also prewet an extra 1" band around the cast shadow to ensure a soft edge. The broken lines indicate the areas to prewet (remember not to add pigment if the shine has left your paper). Lay in yellow paint in the prewet area using your #8 sable brush.

Leave the highlight area white, and do not add pigment in the band of water around the cast shadow. Lift off unwanted paint with a damp sable brush. (Inexperienced painters should work one pepper at a time, drying the paper thoroughly before progressing to the next pepper.) Dry your painting.

The dark shadow areas of the red peppers, the green areas including the stems, and most of the cast shadow areas will need a light blue underglaze. Since it is hard to lighten an area if the paint is applied too dark, apply two or three overlaying light washes to get the right depth of color; avoid making the blue too dark to start with. Dry your painting.

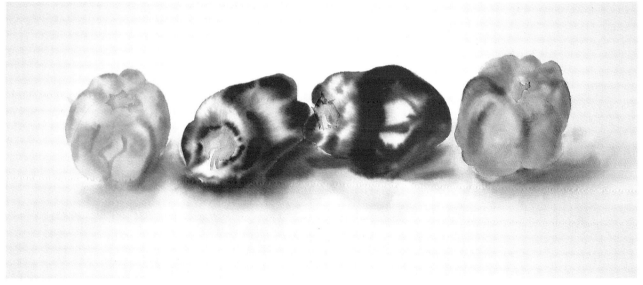

STAGE 2

Work each pepper and shadow individually, using the process just described. The red you paint on the yellow and green peppers is reflected light. Red on the green pepper, apart from where the pepper is red, serves to neutralize the green. Red in cast shadows is reflected from the red peppers. Dry your painting.

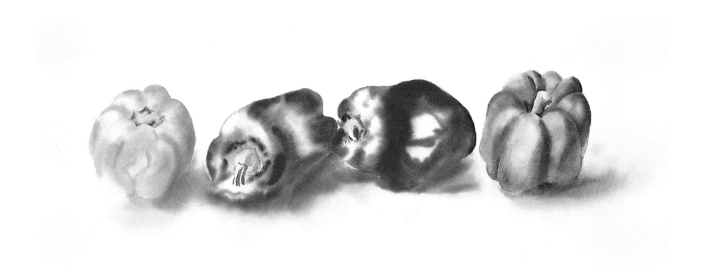

STAGE 3

Squint as you look at the stems. Some parts will be lighter than the color behind them, in which case you should negatively paint them by painting the "back" color darker. Now "sculpt" chunky sections of the peppers, one at a time, and dry the paper between each wash. Subtle colors are achieved with successive layers of individual colors.

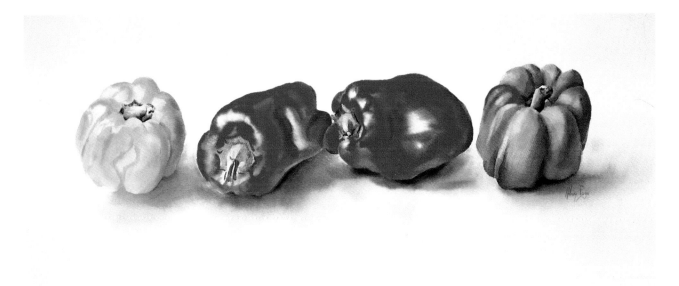

STAGE 4

To achieve a saturated red, rewet the red peppers and shadows and add another layer of red. The yellow sections are refined by working individual sections, as with the green pepper. When the peppers are completely dry, you can work on the cast shadows as necessary. Ask yourself, "Is the pepper's cast shadow darker than the form shadow?" With a dark subject and a light ground, the cast shadow will sometimes be lighter than the form shadow, though usually the cast shadow is darker. Notice how the cast

shadow is particularly dark adjacent to the downward-curving surface of the pepper. By glazing red, blue, and yellow over one another, you will achieve a neutral shadow shade. Soften the outer edge of the shadow with water and dry your paper between each layer of glazing. Add more darks and accents to the stem. To lighten highlights, wet the areas and wipe with a tissue, then erase the same area with an Art Gum eraser.

It is fun adding the final details, because you can begin to see the peppers become vivid and real.

LESSON 3 *Reflected Blue on Red*

This lesson provides the opportunity to study the enveloping influence of blue light reflected from the sky, giving most shadows in outdoor scenes a blue undertone and additional light-color combinations to consider.

A year after I made the original color sketch of the Lord Nelson Pub, I returned to paint it. The resulting picture illustrates the blue-light influence on the form shadows of the red building, and it shows a special technique for achieving the blue underglow. Also covered is how to depict the differences between sunlit desaturated, saturated, and shadow color. Our featured red pigment is cadmium red deep, a paint with a unique tint and granular quality that is useful for portraying naturalistic reds.

OBJECTIVE COLOR

The photograph (p. 95) enables you to distinguish a blue influence from the sky affecting the colored shadows. The upper-left portion shows colors in shadow influenced by white light from the lower section. The upper-middle section shows the same colors in shadow influenced by blue light from the lower section. The lower-right section shows the same colors illuminated by sunlight so bright that they are unaffected by the darker blue color in shadow.

As you can see, the colors influencing the blues in the far upper-right portion make them hardly recognizable as blue: analogous combinations such as the red–blue and blue–green create purple and turquoise, respectively; complements or near-complements cause the influenced color, the one in shade, to be rendered neutral—for instance, the blue when influenced by yellow. Identical or very similar colors, such as the blue on blue, make the shadow color more saturated.

OPTICAL COLOR

The shade of blue chosen for the sky—a phthalocyanine green-blue—works well with the building's red shade. A more purplish ultramarine blue would not create the same mutual color enhancement.

DEMONSTRATION
THE LORD NELSON

COLOR LESSON: Understanding the extent of reflected color

CONCEPT: Painterly rendering of a red building; how to portray blue light reflected into a shadow

SEEING: Reflected blue light in red shadows, compared to sunlit and saturated red

DRAWING: Using rose madder genuine

COLORS: Rose madder genuine, Winsor blue, aureolin yellow cobalt, permanent rose quinacridone, cadmium red deep

PAPER: 15 × 22" T.H. Saunders

BRUSHES: 2", 1", 1/2" flat, #8, #6 round, #3 rigger

ALSO: Masking fluid, T-square, camera, 15 × 22" styrofoam painted with white acrylic, 2–4 bulldog clips

COMPOSITION

Rather than copy the scene shown here, try to find a red building in your area and adapt the demonstration to your requirements. Choosing a time of day for optimum shadow effects is important when you decide to paint a building, for it is no good arriving to paint any old time: you need to

A white and red block influenced by white reflected light.

When compared to the same boxes influenced by blue reflected light, you can see how cool and blue the shadows are.

stake out your subject. The main problem with this composition was getting up early enough to catch the sun casting light on the porch, causing a contrast with the shadowed areas.

PALETTES

Palette 1: Drawing: rose madder genuine (M). *Palette 2:* Blue sky and underpainting: Winsor blue (S). *Palette 3:* Neutrals, sky, trees, and cast shadow: aureolin yellow cobalt (M), permanent rose quinacridone (M), Winsor blue (t). *Palette 4:* Roof, window panes, anchor: aureolin (S), Winsor blue (t), cadmium red deep (S). *Palette 5:* Red building: cadmium red deep (L); add more water for sunlit color.

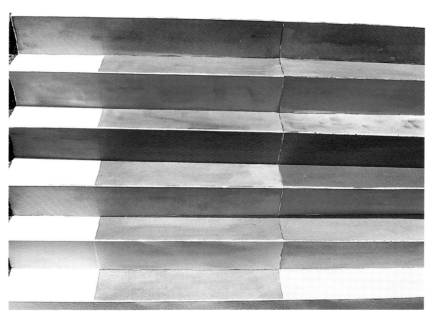

With careful examination you'll see the lighter "influencing" color and the darker "influenced" color in shadow.

This unfinished color sketch, done in under two hours, captured an atmosphere as well as an interesting cast shadow on the porch.

STAGE 1

I chose to draw with rose madder genuine for two reasons: first, the paint lifts readily when agitated with a damp brush and wiped off, allowing for correction; secondly, the color is related to cadmium red deep. I painted the gold lettering on the white paper since I could not paint transparent yellow on top of the red. After an hour or so the light had changed too much for me to continue, so I did the remainder at home using my color sketch and a photo.

STAGE 2

Before painting, I masked some of the foreground tree in front of the building with masking fluid. Contrary to much literature on the subject, cadmium red deep is quite transparent when applied in a single wash. Thus I underpainted, in Winsor blue, the shadow areas of the building influenced by blue reflected from the sky. I knew that when overpainted with cadmium red deep the blue would show through. When this was dry, I prewet the sky and distant trees and then dropped in the colors. While the paper still had a shine on it, I used a rigger brush for the tall diffuse tree in the middle ground.

STAGE 3

At this stage I worked in well-dried sections. For the roof I used a flat ¹/₂" brush, quickly indicating the tiles by dropping in darker color. By prewetting about 2" above the trees, I was able to drop in diffuse trees and at the same time negatively and positively paint the far buildings. The cast shadow's shape, taken from my original color sketch, is a

lighter blue mixture of these neutral colors. Sunlit desaturated red is painted with diluted cadmium red deep. I used thicker paint with less water for the saturated red in shadow painted over the blue. With the paper still wet, I dropped in neutral green foliage around the far window and negatively painted additional branches over and above the masked branches.

STAGE 4

The red cast shadow on the porch is influenced by red reflected from the building. Thus it appears particularly saturated. Notice how the trees' cast shadow falls across the sunlit area, making the color saturated. Notice, too, how the sunlit wall is practically white when compared to the shadow side. Also, the flat-brushed windowpanes in shadow are darker than those in sunlight.

The foreground daffodils are loosely painted so as not to draw too much attention to them. However, the yellow serves to unify the painting by connecting with the yellow in the lettering. I prewet the foreground before laying in the diffuse tree shadows, which I used to draw the eye to the porch, my center of interest.

STAGE 5

If each stage in a painting achieves the correct relative values, then this stage is just a matter of adding the final details—the two signs, and shadows on each window to create a quaint realistic effect. The one consolation of not being able to complete the painting on-site because of bad weather was to be able to sit inside by a roaring fire eating a hearty pub lunch and watching the driving rain!

ROSE TO PURPLE

Confusion encircles colors placed on the color wheel between rose and purple. The original fugitive magenta was a bright red dye, fuchsin, similar in hue to the wild fuchsia flowers, and it was quite similar to printer's magenta or to the "balanced" primary red called permanent rose quinacridone. Its reflectance curve shows that the color reflects over a broad area of the spectrum in both the red and blue wavelengths, giving it great mixing potential. On the other hand, permanent magenta, developed later, resembled the purple color of cultivated fuchsia flowers (below). Violet was identified by Sir Isaac Newton as the color of the shortest wavelength in the spectrum. Steeped in tradition, this family of purplish shades is associated with royalty, the church, spirituality, and sensuality.

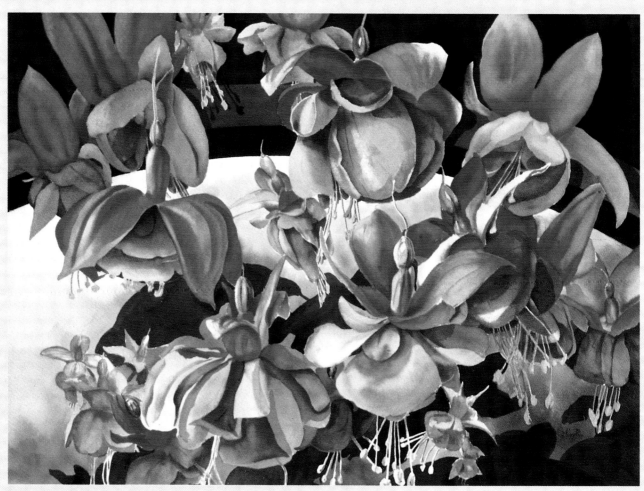

FUCHSIAS II, 22 × 30" (55.9 × 76.2 cm).

LESSON 1 *The Artist's Primary Red*

The featured pigments for this lesson are permanent rose quinacridone and cobalt violet. The demonstration subject is Formosa azaleas.

OBJECTIVE COLORS

By adding a touch of cobalt violet to permanent rose quinacridone, the color perfectly matched the Formosa azaleas in front of me. In sunlight the color is rather light and desaturated. The petals are most saturated in the form shadows, because of their translucent quality. The white paper on which the flowers are resting shows translucent color reflected in the cast shadows.

OPTICAL COLOR

The yellowish hue of the leaves and their darkness in shadow contrasts quite well with the violet-rose, causing a pleasing color combination.

DEMONSTRATION
FORMOSA AZALEAS

COLOR LESSON: Learning the hue of the artist's balanced primary red; seeing subtle color differences

CONCEPT: Botanical study

SEEING: Varying flower colors when petals are in sunlight; their translucent form shadows and their cast shadows

DRAWING: Using color

COLORS: Permanent rose quinacridone, cobalt violet, cobalt blue, aureolin yellow cobalt, permanent blue ultramarine

PAPER: 140-lb. Arches cold-pressed

BRUSHES: #8, #3 and #1 round

ALSO: Blade and Art Gum eraser

COMPOSITION

It is not possible to see subtle differences in petal color without

fresh flowers. Depending on your location you may find either azaleas or rhododendrons to paint: the two are closely linked genuses.

Having located your flowers, place them on a white board either in direct sunlight or with a bright light on them; if in sunlight you can shift the board to keep the shadow shape constant. I frequently brushed clean water on the stems to keep them fresh.

If I took time for value sketch or pencil drawing, the flowers would wilt before I'd finished the painting. However, it is necessary to know how the azalea appears. A typical single azalea flower has five petals joined at the base to form a tube, giving the flower a trumpet form.

Violet, named after the flower, is often called purple, from purpura, the ancient purple of Tyre (Phoenicia).

Each flower has five pairs of stamens. Pointed dark leaves grow circularly around groups of three or more flowers on one stem.

PALETTES

Palette 1: Formosa Azalea petals in sunlight: permanent rose quinacridone (M), cobalt violet (L). *Palette 2:* Translucent petals: permanent rose (M), cobalt violet (M). *Palette 3:* Cast shadow on petals: permanent rose (S), cobalt blue (S). *Palette 4:* Cast shadow on white ground: permanent rose (S), cobalt blue (S), aureolin (S), with cobalt violet (t). *Palette 5:* Leaves and brown stem: permanent blue (M), aureolin (M), cobalt blue (S), permanent rose (t).

In sunlight the azaleas' color is rather desaturated.

99

Here is a guide to six colors I use in the rose-to-purple range, giving their properties, derived from my handling tests, along with the Color Index numbers and components, as obtained from the paints' manufacturers.

Permanent rose quinacridone (PV19, 46500), the color of printer's magenta, does not appear on the spectrum. It is the artist's balanced primary red, not "Coca-Cola red," as is often mistakenly assumed. As such, it is pivotal in color mixing, as evidenced in many demonstrations in this book. Developed for wide use by E.I. Dupont de Nemours, the quinacridones came on the market in 1958.

The physical handling test shows that permanent rose quinacridone is manageable when applied wet-on-wet and does not spread uncontrollably. It lifts minimally when rewetted and wiped, so it is fine for glazing. It is very lightfast, even with exposure to Texas sunlight.

Rose madder genuine (Natural Red 9, 75330) was known in ancient times as rubia tinctorium. Madder roots, resembling dried carrots, are the source for a dye that is chemically related to alizarin, purpurin being the distinguishing ingredient. The spectral reflectance curve shows that the pigment is very similar to permanent rose, which can be substituted for it. Slightly granular, it does not spread uncontrollably when applied wet-on-wet. It lifts readily when agitated with a damp brush and wiped with a tissue. However, this means that it is not good for glazing and overpainting. Contrary to expectation for a natural pigment, rose madder genuine does not fade much when exposed to sunlight. However, it does have a tendency to turn bluer. To counteract this, painters may want to add a touch more yellow than they would normally.

Alizarin crimson (PR83, 58000), dihydroxy-anthraquinone, is a historic pigment. It partially replaced the natural madder color trihydroxy-anthraquinone and was the first natural dye to be synthesized. Alizarin crimson is now considered one of the least lightfast pigments, although when applied reasonably heavily in watercolor (it won't crack as with oils), it is acceptably lightfast. It will not lift when rewetted and wiped. The pigment spreads uncontrollably when applied wet-on-wet; it also "ozzles." Some companies make alizarin crimson hue from naphthol and a quinacridone. These are fine if they match the deep, rich hue of alizarin.

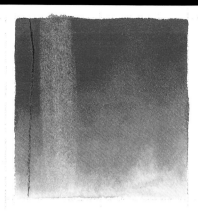

Permanent rose quinacridone

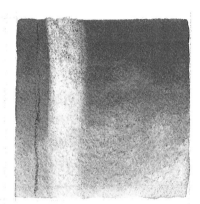

Rose madder genuine

Alizarin crimson

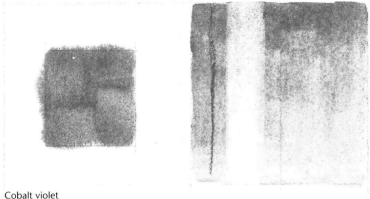

Cobalt violet

Permanent magenta quinacridone

Thalo purple (Grumbacher)

Cobalt violet (PV14, 77360) is made by heating cobalt aluminate and sodium phosphate. Its degree of saturation and self-illuminating quality makes it unique, quite impossible to match by mixing, though it is a very high-keyed and light paint. Cobalt violet has an extremely granular quality and will not lay in smoothly even in wet-on-wet applications. It lifts right off the paper when rewetted, so it is not suitable for glazing.

Permanent magenta quinacridone (PV19, 46500) is very lightfast, unlike the original fugitive organic dye, called fuchsin, produced in France. The pigment spreads when applied wet-on-wet. It lays in very smoothly and does not lift much when rewetted and wiped.

Thalo purple (Grumbacher) (PV23, 51329; PV15, 77007), a blue-purple shade, is the color of the shortest wavelengths. It consists of carbizole dioxazine violet and complex silicate of sodium and aluminum with sulphur (ultramarine). Synthetic organic dioxazine was introduced as a pigment in 1952. The pigment has strong tinting power, so it covers well when applied heavily.

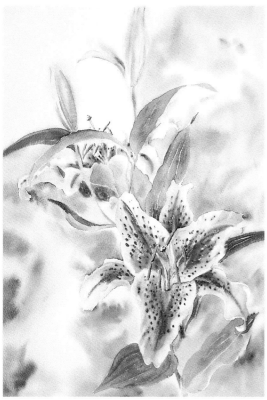

STAGE 3

I made sure my paints on the palette were clean and that some of the blobs of paint on each palette were mixed with water. Then I turned the paper upside down for an abstract-shape approach. I worked wet-on-wet in limited areas, taking care to soften an edge if it bordered another section. I dried each before proceeding to the next area. For an additional flower, I left a soft-edged area of white at the bottom left.

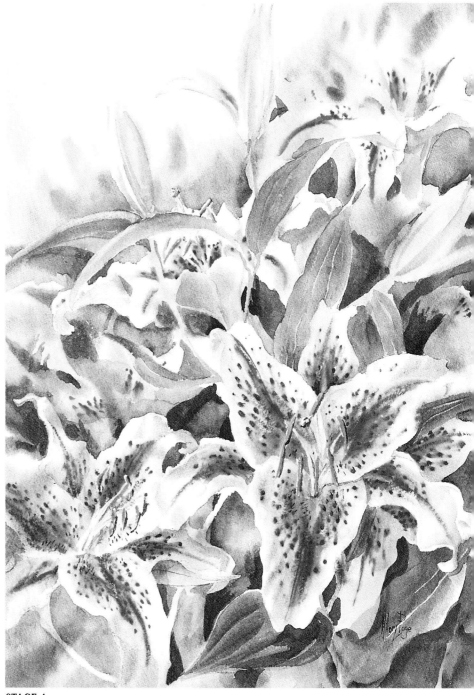

STAGE 4

I painted the details on the flower at bottom left. Using the background colors as a stimulus, I negatively painted other flowers and leaves, working from light to dark colors. I softened edges to give the impression of distance without resorting to bluing the colors. I constantly critiqued the painting by looking at it in a mirror. Larger shapes of similar value began to emerge not related to the positioning of the flowers and leaves. I began to subtly emphasize these to lead the viewer on a path through the painting.

LESSON 3 *Flesh Colors*

Frequently, students come to me with photographs of their relatives asking for help with flesh colors. This lesson does not address the drawing aspect of portraiture, but we will explore the stages of painting *Sarah* as an example of light flesh colors. Here are two examples, also, showing paint mixtures for dark flesh colors and for light-skinned older people. The featured pigment is rose madder genuine.

PIGMENT COLOR

For realistic portraits, in keeping with the degree of lightness or darkness of the skin I paint either a high-keyed or low-keyed painting. For light flesh colors, I use rose madder genuine or permanent rose, aureolin yellow cobalt, and a touch of cobalt blue. By adjusting the amounts of the rose and yellow, it is possible to mix colors ranging from very pink to a golden tone. For darker flesh tones, I use permanent blue ultramarine instead of lighter cobalt blue.

OBJECTIVE COLOR

Reflected color will influence flesh tones, especially on the neck and chin, and will show up more on dark flesh than light. You may realize already that if Sarah had been wearing a yellow dress you would have seen yellow added to her flesh color under her chin. This is seen more readily on darker skin. In *Yvonne I*, I have emphasized the amount of blue-green reflected light on her face. It also serves to enhance her golden brown flesh tones. In *Yvonne II*, I left the area contiguous to her face white to make her flesh color appear darker.

HERBERT, 22 × 15" (55.9 × 38.1 cm).

Older people's skin seems to have more veins on the surface, giving the flesh a bluer tone, as shown in this portrait.

YVONNE I, 22 × 15" (55.9 × 38.1 cm).

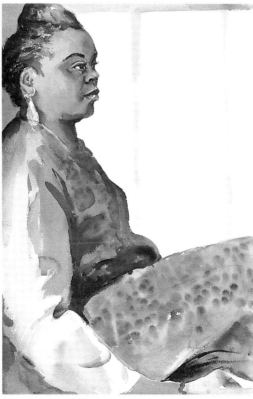

YVONNE II, 22 × 15" (55.9 × 38.1 cm).

Permanent blue ultramarine in the palette for dark flesh colors will give you a range of tones from rich gold to dark brown, as these two portraits, painted from a model, illustrate.

Leaping Color

This lesson utilizes a characteristic of our vision, that of judging a color by comparison. The featured pigment is permanent magenta quinacridone.

DEMONSTRATION
EGGPLANT

COLOR LESSON: Making the eye leap to conclusions

CONCEPT: Stylized rendering of eggplants

SEEING: Colors in direct light and shadow; also reflected color

DRAWING: Finding the subject's abstract appeal

PAINTS: Permanent magenta quinacridone, aureolin yellow cobalt, permanent blue ultramarine

PAPER: 15 × 11" 140-lb. Arches cold-pressed

BRUSHES: #12, #8, #3 round (sable is best)

ALSO: Art Gum eraser

OBJECTIVE COLOR
Ripe eggplants you see in the store are darker than those shown growing here; in fact, they are almost black. If observed in sunlight, however, even the darkest eggplants will appear colored. The dark, shiny surface provides optimum conditions for seeing the highlight and showing lighter colors reflected in its surface. In this example, you can see color reflected from the leaves and sky.

OPTICAL COLOR
To make the eggplant appear very dark yet still colored, I juxtaposed it with a light background. To enhance the color's saturation and beauty, I used a near-complementary green, as shown on the contrast color wheel. More significantly, I added a border of saturated magenta. As you will recall from studying color modification (page 37), if two colors that are close in hue are placed quite far apart, the eye tends to leap from one color to another, make comparisons, and jump to conclusions. The light magenta border here serves this purpose. It is similar in hue to the eggplant, only lighter. The eye compares the eggplant with the colored border and concludes that the eggplant is lighter and more colorful than it really is. Try blocking out the border, and the eggplant will appear rather dull and dark.

COMPOSITION
Work out your design in a drawing on tracing paper. I was aided by several photographs and two eggplants. I transferred my design to the paper using a light table.

PALETTES
Palette 1: Border: permanent magenta quinacridone (M). *Palette 2:* Olive leaves and background: permanent magenta (S), aureolin yellow cobalt (L), permanent blue ultramarine (M). *Palette 3:* Eggplant: permanent magenta (L), permanent blue (M), and aureolin (S).

I used this photo of eggplants as a starting point for a painting of the shiny almost-black vegetables.

STAGE 1
On dry paper with my #8 brush, I laid in a graded wash around the border, lightening it near the eggplants. I prewet the leaves before laying in a modulated yellow-green. Doing each eggplant separately, I began by painting a clear-water shape. Then I loaded three brushes— one with olive green reflected color, one with magenta and aureolin for the eggplant in sunlight, and one with permanent blue added to the eggplant color for the reflected sky. With an even, wet shine on the paper, I dropped in the paint. I completely dried the paper before proceeding.

STAGE 2

I laid in the left-hand background to have a value against which to judge values of other leaves. I prewet the background and then dropped in blue and green. Using water and a tissue, I quickly lifted highlights on the eggplant near the leaf's cast shadow. I laid in stalks each time, spreading water where needed to lay smooth washes. I added more positive leaf shapes.

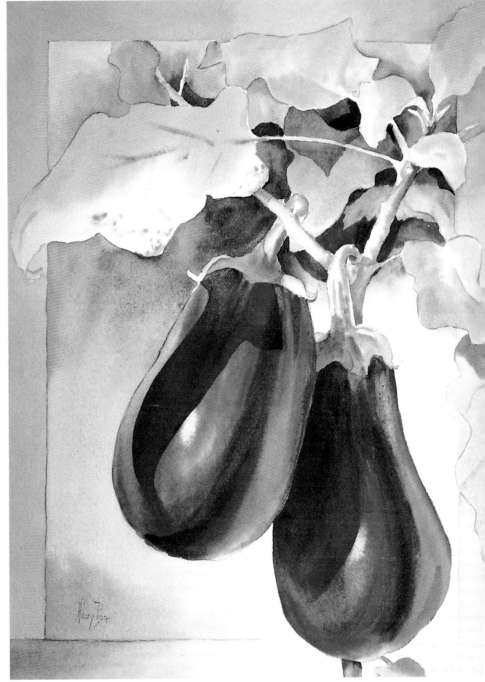

STAGE 3

When the paper was dry, I lightly penciled in the cast shadows on the eggplant. I then laid in dark magenta and aureolin for the shadow cast by the leaf, and I painted a shadow cast by the first eggplant on the second. I continued positive painting of background and leaves, squinting to check for a pleasing abstract pattern. Then I carved out a few negative leaves by adding darker shades.

I now added another eggplant! I sharpened the core of the highlights by lifting and then erasing. The darker leaf area curves to draw the eye to the eggplants, as does the juxtaposition of hard-edged dark and light. The positive leaf shape above and to the left of the eggplant is echoed in the negative shape to the right.

STAGE 4

Subtle shadow effects can also be achieved by glazing. Notice the boy's bench seat. Here the darker cast shadow on the top surface makes the reflected light glow.

Reflections occurring directly below an object are darker than the original image. Squint and you will see that the reflection and canoe are one shape which then merges with the foreground. For subtle variations in the reflection, lift some pigment with a damp sable brush used as a sponge.

You will find many overlaying washes are required before you achieve the glowing effect characteristic of the final painting, but it can be achieved in no other way.

NOTE:

To lessen the impact of the dark stern silhouetted against the dazzling water, paint a band of alizarin crimson hue slightly lighter in value than the dark blue. This sets up a vibration and is more interesting than softening the edge or using a band of light blue.

ROCKPORT HARBOR, 11 × 15" (27.9 × 38.1 cm).

Using colors to convey mood: in this case, blue, red, and orange helped me capture a cheerful atmosphere, that of Maine's Rockport harbor on a sunny afternoon. I ignored my visual observations in the interest of creating mood, and in this painting the colors, especially background ones, are not realistic at all. I began with a blue underwash. The dominant color becomes blue because it takes up the largest area on the paper; also, it combines with turquoise to increase the blue effect. The checkerboard placement of the orange reduces its general color impact but serves to emphasize the brightness of the contiguously placed green-blues. Conversely, as a near-complement, the blue increases the appearance of saturation of the orange.

GREEN

Emerald green is the color of healing. Sap green is the color of new life and fertility. Conversely, green is the color of envy, jealousy, slime, poison, and the alien. Before viridian and phthalo green pigments were discovered, the color we know as phthalo green was known to exist only as the unique turquoise color of peacocks' feathers and the green ring on a duck's neck, as observed by Leonardo da Vinci. Even scarcer for centuries in the West were the fluorescent yellow-greens of exotic tropical birds. Spectral reflectance curves show that greens, as secondary colors, do not reflect wavelengths over a broad portion of the spectrum. Thus they do not possess much color-mixing potential.

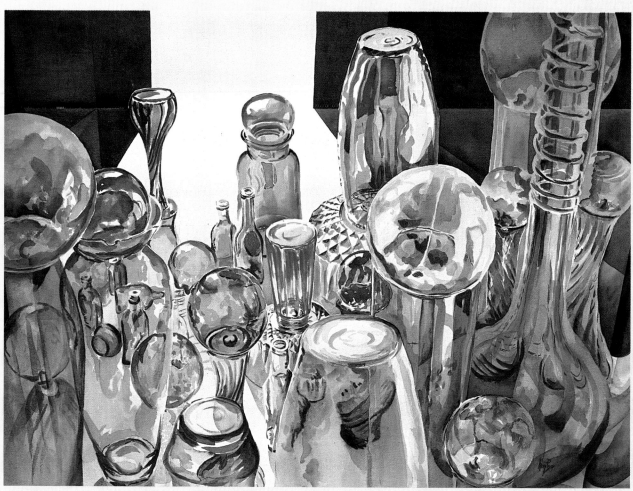

GLORIOUS GLASS, 22 × 30" (55.9 × 76.2 cm).

OBJECTIVE COLOR

Natural greens are extremely varied in hue, ranging from the yellowish green of a fresh Boston lettuce—as in premixed sap and Hooker's green and permanent green—to the neutral khaki green of a late-summer tree—as in oxide of chromium and terre verte.

A yellow-green can be mixed from phthalo blue or phthalo green, together with Hansa yellow or aureolin yellow cobalt and a touch of permanent rose to make it more neutral and natural. It is not possible to make saturated greens from French ultramarine and ultramarine deep—those blues are too purple. However, it is possible to make a natural green using permanent blue ultramarine, which is a slightly greener blue.

OPTICAL COLOR

The contrast color wheel shows that natural greens are particularly enhanced by violets, mauves, and red-violets.

DEMONSTRATION
GREEN PALMETTO PALMS

COLOR LESSON: Mixing an unsaturated green; using harmonious colors dynamically

CONCEPT: Rendering of palms in a geometric design

SEEING: Shapes of fronds seen from at least four angles

DRAWING: A value sketch using no lines; using cut-outs

COLORS: Aureolin (Holbein), permanent blue ultramarine, permanent rose quinacridone

MATERIALS: 6B graphite stick, 3B pencil

BRUSHES: 2" and 1" flat, #14, #8, #3 round

PAPER: 15 × 11" or 15 × 22" 140-lb. Arches cold-pressed sketchbook

ALSO: Rags, paper towels, card stock, scissors or blade

COMPOSITION

This seemingly complicated composition is really very simple if you work systematically.

Search your neighborhood or go to the nearest nursery to study living palms up close, or consult the photograph. Draw four separate palm shapes as illustrated. Cut around these to make templates. One palm needs to be especially interesting, perhaps with several leaves bent over. This will be your center of interest.

VALUE GUIDE

Instead of making a detailed value sketch, make a loose indication of a passage of light for flexibility.

Observe how shadows fall on the palm and how the individual leaves are joined as they fan out from a triangular structure on the stem.

Place your templates on the paper, overlapping as shown, to give you a general idea of placement. Then trace the design.

Leave white where you want the center of interest to be. Place your value guide so you can see it as you paint. By the second or third wash, you will be in a position to add more detail to your sketch, since then you have the exact placement of the center of interest.

PALETTES

Palette 1: Light green: aureolin (Holbein) (L), permanent blue ultramarine (S). *Palette 2:* Rose and blue: permanent rose quinacridone (M), cobalt blue (M). *Palette 3:* Rose and orange: permanent rose (S), aureolin (S). *Palette 4:* Dark green: permanent blue (L), aureolin (S), permanent rose (t).

STAGE 1

Load your 1" flat brush with yellow, your #14 round brush with light green, and your #8 alternately with rose and violet. Wet your paper with a 2" brush and place it on a cloth on your plexiglas. Lay in pigments, taking care to leave the center of interest area unpainted. Do not add paint once the shine has left the paper, or you will make a muddy mess. Dry your painting with a hair dryer once the shine has gone.

STAGE 2

Place the most frontward frond where you left the paper white in your original wash and trace it. Check your palettes to make sure you have enough paint mixed. Load your brushes as in Stage 1, and wet the paper everywhere except the frond. You may need to use your #3 brush to wet around the detailed areas next to it. Lay in a second layer of the same colors already on the paper and dry your painting.

STAGE 3

Lay on templates of the next-to-frontward fronds. You may need to adapt the shape of the template for a more pleasing design. Trace, but without drawing over the front frond, to make subsequent fronds appear behind it.

Work in small sections of trapped negative space. For a smoother paint application, you may want to wet an area and drop in the paint. If you paint colors that are related in hue and close on the color wheel over the original color, the resulting combined color will be reasonably saturated. If you want more neutral shades, overlay near-complements as shown on your pigment-color wheel.

Darker colors painted in the negative space need to appear to travel continuously behind the positive palm shapes. Don't mechanically fill in every negative space. I've left the bottom untouched for future dramatic contrast.

The shady side of palms are translucent and appear two-toned. At this point you can paint the lighter part of the shadowed palms and underpaint where the darker areas will be. Also add more negative fronds as shown at top left. By now you may not even need to use the template. Restate some of the negative fronds already painted, if necessary. Squinting helps you see underlying value structure and viewing your painting in a mirror helps you see it with fresh eyes. Adjust areas to make a stronger design.

STAGE 4

Make thin lines to delineate the various surfaces of individual palm leaves before you creatively paint cast shadows. Notice how shadows "staircase" across a sunlit palm and how they are darker where the surface does not face the light and bluer where it faces the blue sky. Finally, add darks and accents to draw the eye to your center of interest. Remember, the viewer is drawn to areas of bright color, especially yellow, and to areas of high value and color contrast.

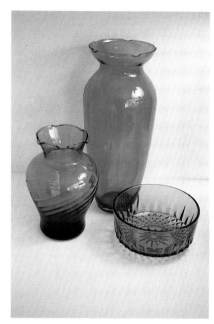

I added a blue vase to the composition for variety.

STAGE 2

I tilted the board to about a 30-degree angle and with my round #12 brush painted the tall vase with Winsor green and with a little reflected background color at the side. I repeated the process for the small bowl using viridian, a slightly more neutral green. For the small vase, rather than use a granular ultramarine, I mixed an appropriate smooth-textured violet-blue from permanent blue and permanent rose. Since glass does not have shadows to anchor the vessels to the ground, I penciled in horizontal and vertical lines to indicate a third dimension. I then turned the paper upside down and wet the background. I dropped in color, making a hard edge on the light side of the vase and at the penciled edge. By diffusing the inside edge, I made the whole area appear toned because of the Craik–O'Brien contour.

STAGE 1

I spent some time prewetting the background with a 1" flat and a small brush for intricate areas. I transferred the wet paper to my cloth-covered plexiglas board and then used my flat 1" brush to drop in the background colors in the order set out in the palettes above. I then dried the painting and masked the highlights.

STAGE 3

I painted the lightest reflections. Then, before painting the middle-valued reflections, I removed the mask from the highlights and lowered the values of some of them. Notice how the tall green vase reflected in the blue one influences the color of the blue. Conversely, the green bowl and blue vase influence the shade of the reflections in the blue vase.

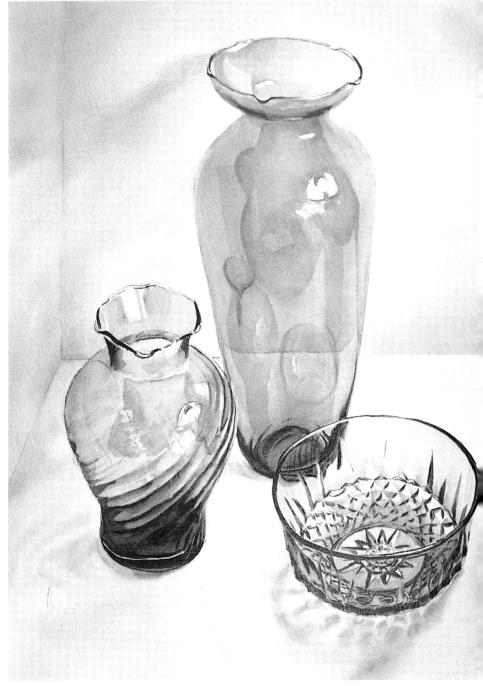

STAGE 4

Reflections off a smooth surface are hard-edged. Thus I added more hard-edged masses. For the dark pattern on the small bowl, I added Winsor green, for viridian, like cobalt blue, is an intrinsically light-values pigment. Notice how the green color becomes much darker where the two green surfaces overlap. Shadows and background had to be adjusted. The final stage of a painting, especially for an intricate subject such as colored glass, calls for a great deal of observation.

LESSON 3 *Iridescence and Fluorescence*

Iridescence occurs on a pearl, a soap bubble, and, as in the following demonstration, on a parrot's tail. But you will have to check the effect for yourself—the printing process cannot duplicate iridescent colors.

OBJECTIVE COLOR

The brilliant color effect known as iridescence revealed to artists of earlier times certain colors before the pigment colors were invented. An example of this is in peacock feathers; the color of the phthalocyanine blues and greens were not made until the 1920s. But how can we portray the effect of iridescence?

PIGMENT COLOR

Nature has provided the artist with a special type of "self-illuminating" pigments perfect for portraying iridescence. These paints are known as fluorescent pigments. The phenomena of fluorescence occurs when a surface absorbs photons in one portion of the spectrum, such as ultraviolet, and gives off energy or light in another. Added to the light reflected by the pigment in the usual way, fluorescence gives an extra brightness. Unfortunately, many fluorescent pigments are not very lightfast, so you may wish to test them first. Yet some pigments with mild fluorescence appear quite lightfast, such as Holbein's Opera, a very bright rose color. Cadmium yellow lemon, also manufactured by Holbein, seems to be self-illuminating, though no fluorescent pigment is added to the cadmium to cause this. This color is perfect for our lesson on painting the Amazon parrot.

OPTICAL COLOR

The perfect contrast complement for the yellow-green of permanent green

light is a blue-purple. However, sometimes a subject demands discord. In *Rain Forest Fantasy,* below, the constant bickering among the parrots is an instance where discordant color seemed appropriate. Thus the colors chosen to go with the yellow-green birds have no particularly harmonious relationship on the contrast color wheel; they are neither complementary nor analogous.

DEMONSTRATION
YELLOW-HEADED
AMAZON PARROT

COLOR LESSON: Using bright yellow-greens

CONCEPT: Study of iridescence

SEEING: Intricacies of bird representation

DRAWING: Cursory understanding of bird physiology

COLORS: Aureolin yellow cobalt, permanent rose quinacridone, alizarin crimson, permanent blue ultramarine, permanent green no. 1 light, cadmium yellow lemon

PAPER: 140-lb. Arches cold-pressed

BRUSHES: #8, #3, #1 round, #3 rigger, 1" flat

COMPOSITION

At a pet shop and at the zoo, I did on-location sketches, choosing to have the bird in a sitting position for the study. (It was the only time it was still even for a few seconds!) To simulate its perch and typical rain-forest vegetation, I placed the parrot in a fruit-bearing tree.

After the on-location sketches, it is important to study feather placement, as shown in the line drawing. Here, the flight feathers fold and are covered by the less colorful overlapped feathers.

Each body feather appears curved and fuzzy-edged. The brightest colors occur on the head and the flight feathers. The tail, when extended, is quite iridescent.

PALETTES

This is a small study, so the amount of each color you squeeze out will be relatively small.

Palette 1: Yellow, orange, and red: aureolin yellow cobalt (S), permanent rose quinacridone (S), alizarin crimson (M). *Palette 2:* Iridescent feathers: cadmium yellow lemon (Holbein) (S). *Palette 3:* Green feathers and blues: permanent green no. 1 (light) (L), aureolin (S), permanent blue (S), permanent rose (t). *Palette 4:* Blues: permanent blue (t). *Palette 5:* Beak, branches, background: permanent blue (S), permanent rose (S), aureolin (S).

The profile of combined head and curved beak is round. Both the upper and lower beaks are hinged, a trait of the parrot family. Of the four claws, the two middle ones face forward and the outer ones face backwards. The body form is ovoid.

STAGE 1

With your 1" flat brush, wet the entire parrot image except for the beak and feet. With your #8 brush, drop in yellow on the head, leaving white around the eyes and in the front part. Put in the yellow also on the wings, tail, and legs. While the paper surface is still shiny, drop in red and blue on the wings and tail. Dry your painting.

STAGE 2

Rewet the bird's body, but on the wing wet only about an inch of the upper wing to ensure a soft edge moving down from the back of the head. Drop in green for the body feathers. The green should be brighter on the underside of the body. While the paint is still wet, use your #3 round brush to paint the shadow under each feather in a darker blue-green. Dry your painting.

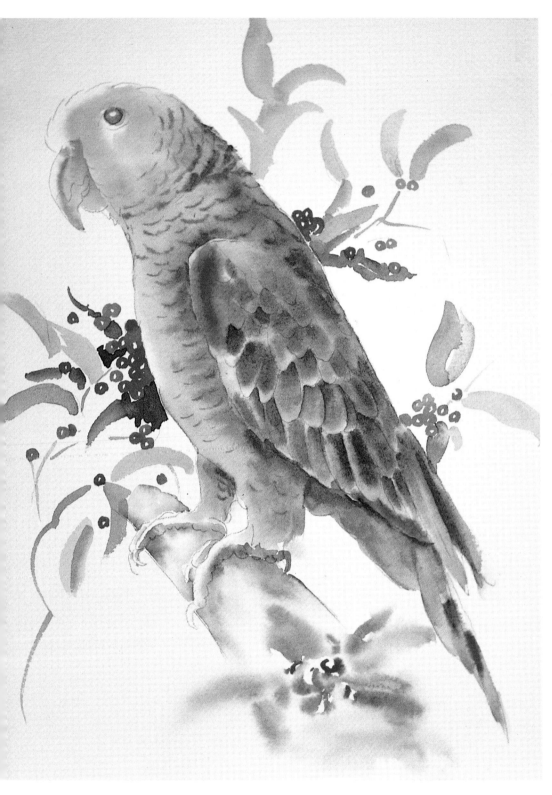

STAGE 3

Rewet the wing feathers. Drop in various shades of green to indicate individual feathers, as shown. In a neutral beige, paint the shadowed underside of the feet and also the beak, which is slightly yellower than the feet. Be sure to drop in the core shadow on the beak to indicate its curved surface. In a bright orange, paint the outer rim of the eyeball. Next paint the branch and then dry your painting.

The under-feathers need to be shaded so that, from the hard and darker edge where another feather overlays it, the shadow thus indicated merges into softness. Now overpaint the yellow tail feathers with cadmium lemon yellow to indicate the iridescence. The "feathery" edge of each feather can be indicated with a special brush use. Pick up a small amount of dark green paint on your rigger brush, flatten and splay the brush hairs, and then drybrush the lower edge of each feather.

Besides the black for the eye's pupil, there is a shadow around it and a highlight on its surface. Finally, wet the background before dropping in a neutral, reddish gray color. Adjust values and design as you see fit. Such detailed studies enable you to progress to making interpretive, unique paintings.

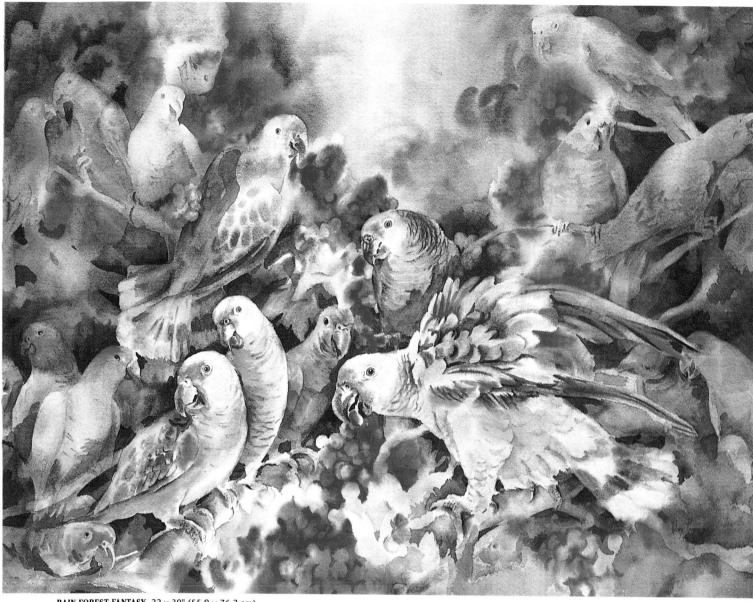

RAIN FOREST FANTASY, 22 × 30" (55.9 × 76.2 cm).

Here I imagined parrots in a lush setting with the birds somewhat camouflaged, as they are in the wild. I chose to paint the blue-fronted Amazon parrot this time; its color is even more interesting than the yellow-headed parrot's. Having no single photograph to follow, I made sketches of birds in many positions. Then, having placed them within a composition, I made a loose color sketch to form an idea of how the colors would look.

The first wash was applied wet-on-wet after I had carefully premixed all my colors. When the paper was dry, I deepened colors in the background, working about a quarter of the painting at a time. I negatively painted the birds in the foreground. It took a lot of thought and time bringing out the underlying structure while, at the same time, keeping it from being obvious. Finally, I worked on the details in the foreground. The overall result is an unusual and vibrant painting.

With the yellow-green demonstration completed, we've come full circle in our color study. Once you have assimilated the information, worked through the exercises, and adapted the demonstrations, it's time to put the studying aside. You should be in the position of a former student: She said at the finish of a workshop that she hadn't realized earlier where all the different aspects of color to which she was being introduced were leading. She remarked: "Now I can see how the strands related to color come together—physics, vision, objective, optical, pigment color, and color theory. I feel, as I embark on a painting, that I have a grasp of what color is all about and at last I can get it right, from the start."